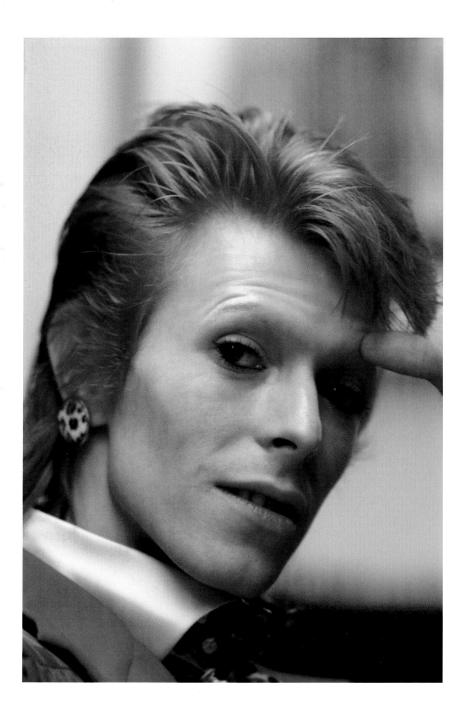

"HE WAS A SWEET, SWEET SOUL.
SUCH A PRIVILEGE TO HAVE KNOWN
AND WORKED WITH HIM. SUCH
A REMARKABLE MAN AND ARTIST.
I LOVED HIM."

— MICK ROCK

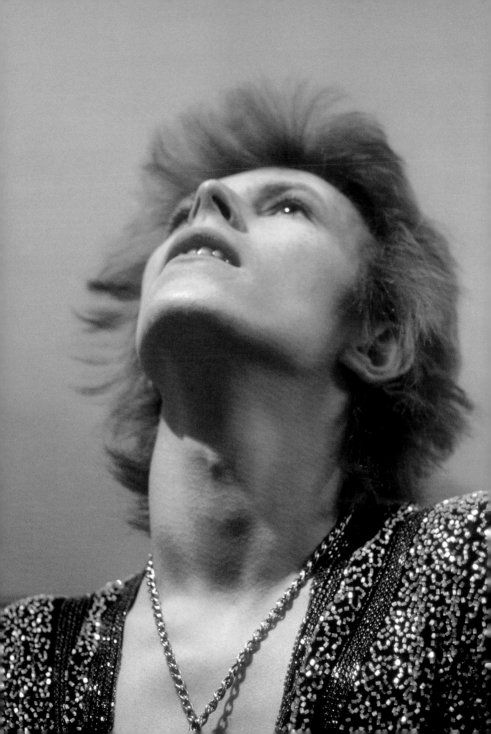

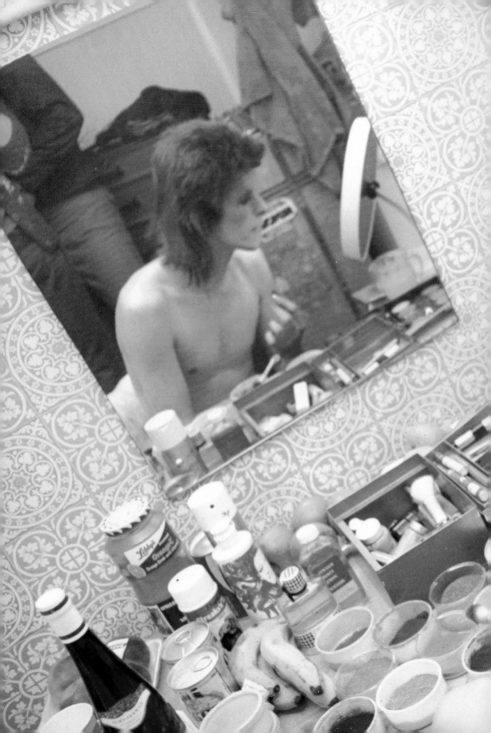

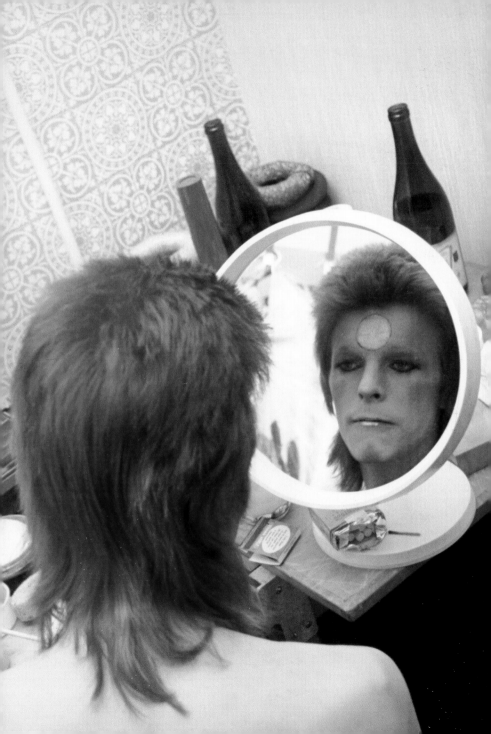

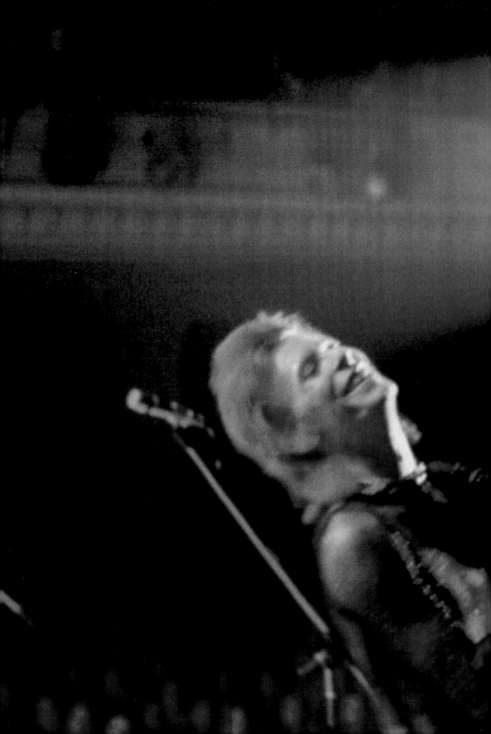

MICK ROCK

THE RISE OF DAVID BOWIE

1972–1973

TASCHEN

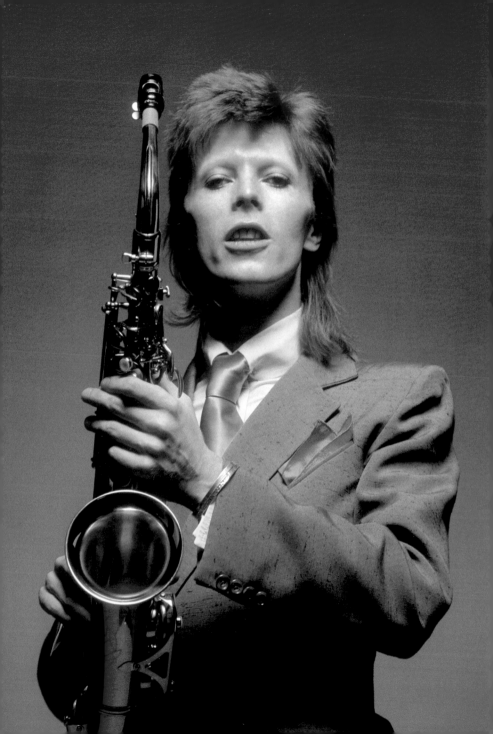

"I COULD MAKE A TRANSFORMATION
AS A ROCK 'N' ROLL STAR."

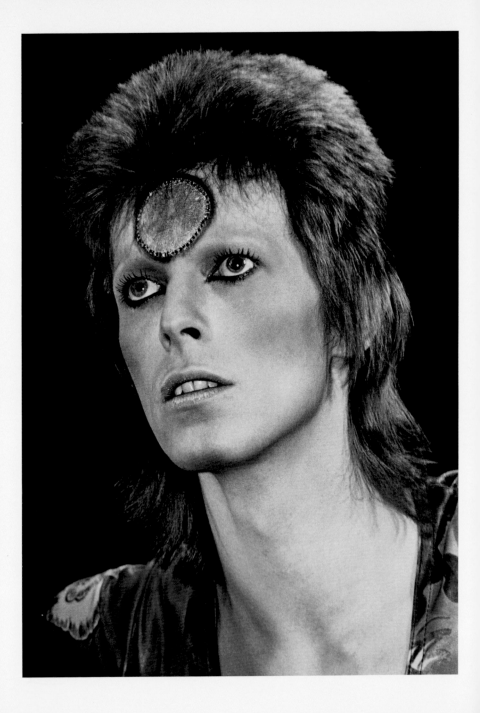

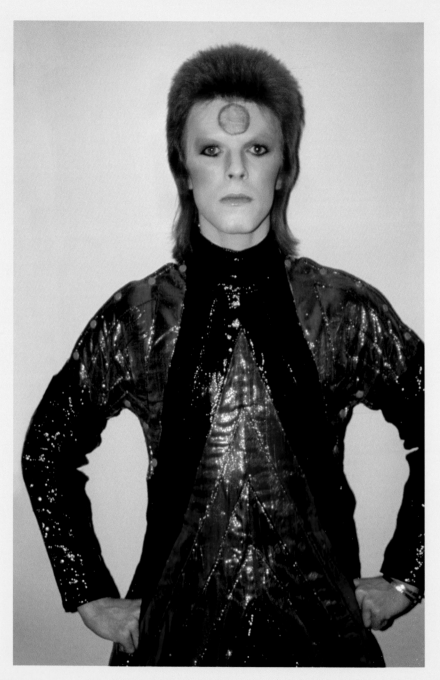

THE SHOCK OF THE NEW, ELECTRIFIED

ZIGGY STARDUST AND DAVID BOWIE

BY MICHAEL BRACEWELL

The photograph shows the interior of a British theatre: white bare walls rising up from the balcony to dusty corners — a place that seems unchanged since the years between the two World Wars.

But now it's the early years of the '70s, and to judge from this picture it might seem to the thousand or so young people who are packed, ecstatic, into this hall that some entirely new possibility for life is being seductively, bewilderingly, thrillingly opened up on the stripped-back stage before them. David Bowie is in town, performing as Ziggy Stardust and the Spiders from Mars, and it's an unforgettable trip . . .

The photo records the faces of the crowd on that enchanted evening: entranced, joyful, entreating, mesmerised, alert, intent. In front of the stage itself, they crush together in a single mass of thick hair and pale flushed cheeks, impelled to a gesture less of contact than of communion.

It is as though an old order that has held things in place for so long has suddenly and triumphantly — with barely a thought for its dissolution — been vaporised into extinction by the action on the stage. And the leader of this revolt, its inspiration and hero, is also — to the clear young eyes of the '70s — unlike anything or anyone that they have ever seen before . . .

"YOU'RE THE BLESSED, WE'RE THE SPIDERS FROM MARS..."
— DAVID BOWIE "HANG ON TO YOURSELF"

The young rock 'n' roll star is male, yes, but beautified — and then beautified again, beyond feminine beauty to what seems more like a Cubist arrangement of shadowed, powdered and painted facial bone structure. What boutique or spaceship could have hatched this balletic, shock-haired, controlling, flirting emissary of self-knowing cool? His own image is right now being reflected back to him off the front of a T-shirt, worn by a cheering girl looking up, hands raised, mid-cheer...

Is this futuristic street style or some strange new form of ritualistic theatre? Certainly, the "look" of the star on stage (an alloy of sex and glamour and high aesthetic extravagance) and his hard-playing sidemen appear to have no affiliation whatsoever to any known style of pop and rock fashion. His entire appearance is more like a manifesto than a style statement. And it's so extreme.

HE WASN'T THINKING ABOUT MONEY, HE WAS THINKING ABOUT STARDOM.

It seems to assert that even rock 'n' roll, the music of sex and rebellion and outsider cool, has suddenly encountered an evolutionary shift — embodied in this star who has taken the musical and visual language of rock 'n' roll beyond any known incarnation. And in so doing created an imaginary new world, from which these electrifying, heart-rending songs are a visceral and all-engulfing transmission.

The whole *phenomenon* of "Ziggy Stardust" — as an album, a tour, a mass subcultural movement — is like an update of the furore that prompted legendary rock critic Lester Bangs to write of Elvis Presley's "Heartbreak Hotel" (1956) that it was not so much a record as a "psycho-drama". By which he meant that the social and hormonal condition of the then newly invented "teenager" had just been given a new musical form that doubled as a ready-made lifestyle: an intoxicating, erotic, cathartic musical theatre that acknowledged, reflected and stimulated something deep within themselves. It had to do with desire and frustration and youth and anger and alienation and sex and boredom and melodrama and excitement, which hitherto they had not been able to articulate.

Routinely hailed as one of the masterpieces of the rock canon and an epoch-defining work of creative iconoclasm, David Bowie's 1972 release *The Rise and Fall of Ziggy Stardust and the Spiders from Mars* brought commingled visions of apocalypse, desire and existential crisis to a global pop audience. And from the outset, Ziggy was a record and a cultural phenomenon that seemed to be concerned with time, time travel and temporality.

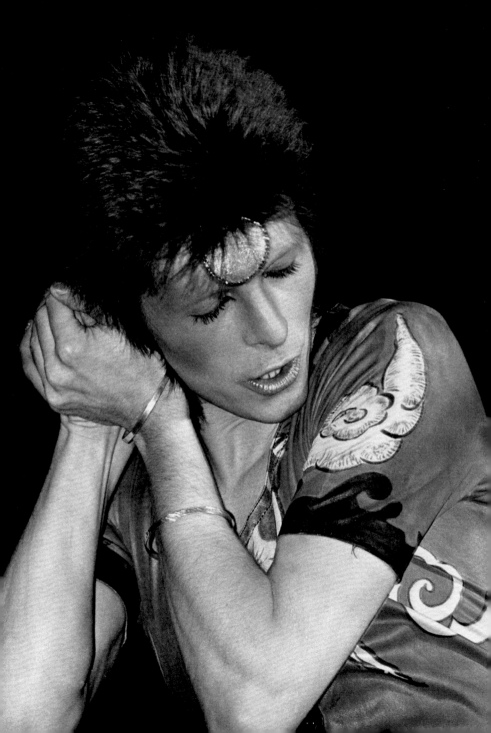

This was enhanced by its historical context. Britain, in the early years of the '70s, was a place still partially immured in the drabness and formality that had lingered since the post-war years of the '50s. Seen now, the landscape of those years appears as shabby and simplistic as that bare theatre — an old modernity in the last throes of wearing itself out. Ziggy, as it transpired, made his lightning strike of intervention at precisely the point when the apparent exhaustion of an old order rendered all the more incisive his presentiment of the future.

But what kind of future was Bowie's on-stage avatar describing in these songs: was it one of "darkness and disgrace" (as

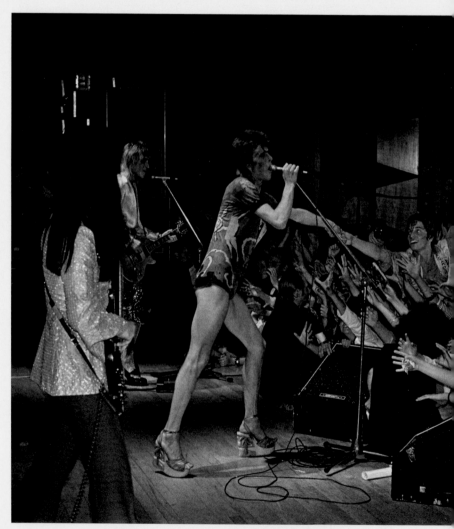

the eye-witnessing narrator-fan-adorer sings of those sung in turn by "Lady Stardust") or some more complex palette of moods from suicidal reverie to orgiastic incitement? We can't get enough of that doomsday song, clearly — and in one fairly fluorescent sense *Ziggy* conjured the notion of rock 'n' roll for and at the end of time, which in turn became a metaphor for the end of youth, the end of love, the end of innocence, the end of utopian fantasies. A soundtrack, at any rate, to the universal experience of finitude — that point at which the dream, any dream, becomes circumscribed by the realities of change and time and mortality.

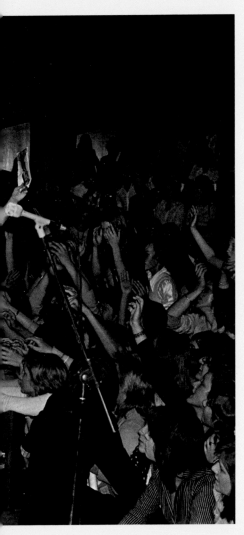

The opening seconds of the opening track on *Ziggy Stardust*, starkly titled "Five Years", sounded like the aura of portent in the most pared-down musical form: fading in from silence, a simple drumbeat, almost military, part-funereal, but mostly indicative of the passing seconds. From this to an introductory piano chord, backing a guitar — like the first flourish of an abbreviated and melancholy overture, tinged with cinematic drama.

And then a young man's voice, hollow, impassive, weary, closer almost to speech than song, as though beyond emotion, concussed with shock: *"Pushing through the market square, so many mothers sighing..."* From the simplest musical form of a single drumbeat, through piano, guitar, vocals and echo, "Five Years" builds through orchestral strings to a point of near hysteria. The song reports the breakdown of daily life in the wake of an announcement of Earth's demise in five years, the observational detail of the lyric all the more potent for possessing at first the impersonality of reportage: *"A girl my age went off her head, hit some tiny children..."*

Yet this account of time reaching critical mass, of the declared end of time, intends more than a science-fiction fantasy. The song invokes images of love — romantic, religious and maternal — as though also addressing the frailties of emotion; that people are kinder, more real, than the times they live through. Ziggy's "sense of an ending", interrupting the flow of time, is as astute a metaphor as it is musically beguiling and dramatic.

Pop and rock music had looked into the dark maw of finitude before: The Rolling Stones, Bob Dylan, The Beatles, The Doors and more had pondered in their different ways upon the end of time. And yet *Ziggy Stardust*, as its territory was defined by its opening track, was exploring the notion of humanity *in extremis* in a very different way — not as lament, or sentiment, or melodrama, or politics, but as an open-ended charade through which to explore the myth of oneself and the mythology of pop.

Ultimately, Bowie seemed to be playing with the notion of modernity itself as a concept that had reached critical mass. Even in 1972, a critic for *The Times*, Michael Wale, described Bowie's work as "T. S. Eliot with a rock 'n' roll beat", thus comparing the vision of "Ziggy Stardust" with the famous British poet's lament for a dying civilisation, "The Waste Land".

Endings, death and suicide are the unlikely principal subjects of this multimillion-selling, chart-topping album. And in the character of Ziggy, the ultimate pop star (the word "star" recurs throughout the record)

ZIGGY STARDUST WAS AN OPEN-ENDED CHARADE, EXPLORING THE MYTH OF ONESELF AND THE MYTHOLOGY OF POP.

became simultaneously the embodiment, executioner, undertaker, and sacrificial victim of pop as an erotic and cultural archetype: the suicidal demigod of all the Jung dudes.

In the half-decade prior to the release of *The Rise and Fall of Ziggy Stardust and the Spiders from Mars*, the greater part of rock music had been primarily inward-looking. At a glance, it seemed as though the release of The Beatles' *Revolver*, in 1966, had marked a gear change in the rock culture zeitgeist: to borrow from William Blake, the Songs of Innocence were over and the Songs of Experience had begun. A darker proposition by far, their directives additionally shaped by a burgeoning drug culture that affirmed the inner journey as the only one worth taking.

Politically and socially, the latter half of the '60s cocooned a so-called counter-culture much given to subsectioning various ideals from Mao to Flower Children to tack-spitting Angry Brigade nihilism to the greasy shallows of the truly Occult to simply letting it all hang out...But then the dream burned out instead (the obscenity trial of the highly influential, countercultural underground magazine *Oz* in June 1971 might be seen as the death rattle of the hippie dream) and nobody had got back to the garden promised by myriad free festivals.

What defiantly arrived in its place were Brutalism, hangover skies the colour of a week-old bruise, rain-slicked concrete precincts, the rise of a new generation on fast drugs who took a swaggering delight in the capacities of artifice and synthetics from green snake-print lurex to eyeliner to primitive electronics. In short, a subculture of slowness (call it somnambulist, call it meditational, call it stoned) had been replaced by a subculture of speed and acceleration. (*"Tony went to fight in Belfast, Rudi stayed at home to starve..."*)

And all of this was embodied in Ziggy Stardust, while also affirming that the end of youth was the end of a dream, and that "queerness" could be both a sexual choice and a performed metaphor for a cultural choice — the Outsider inhabiting a shadow world of counter-morality.

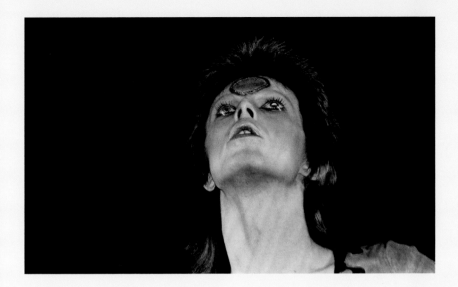

But it all came back to the music, and Ziggy's musical message took to the mass media as though born solely for that mission. The legendary performance of Bowie's "Starman" on the BBC's weekly pop show *Top of the Pops* left parents and children alike in stunned silence, jaws dropped, eyes fixed unblinking to the screen in the corner of the sitting room.

The music was luxurious yet barbed, its sweeping chorus at once heroic and yearning and reassuring — an anthem for the doomed youth of suburbia. The song seemed to begin with cool staccato poise, scene-setting in what might have been the languorous dark of a spring night, with the radio show as the space transmitter that beams a Messiah of liberating newness. Meanwhile the song structure was held firm and sure by arc welds of electric guitar and a drum sound as solid as a landing strip.

In musical terms, the intoxicating energy of *Ziggy Stardust* lay in its simultaneous reclamation and reinvention of the classic forms of pop writing. The near-classicism and tightness of the music — be that the proto-punk of "Hang On to Yourself" or "Suffragette City", the high romance of "Lady Stardust" or the darkling crescendo soliloquy of "Rock 'n' Roll Suicide" — provided containers strong enough to assert the sheer radicalism, rallying Otherness and sci-fi strangeness of the album's overall vision. The clothes, the make-up, the hair — once you realised the intensity of the *music* — made perfect sense: *of course* that's what Ziggy and the Spiders would look like! What did you expect? Not a smile in sight, when on duty. Yet offering something new and something better, beyond the bare walls of this theatre. We're the blessed, they're the Spiders from Mars.

12 UK Summer tour, May–July 1973.
15 Oxford New Theatre, England, 26 June 1973.
16–17 Reaching into the audience to touch a fan's hand, Guildford Civic Hall, England, 27 May 1973.
19 Oxford New Theatre, 26 June 1973.
20–21 "The Jean Genie" promo film shoot, San Francisco, 27 October 1972.

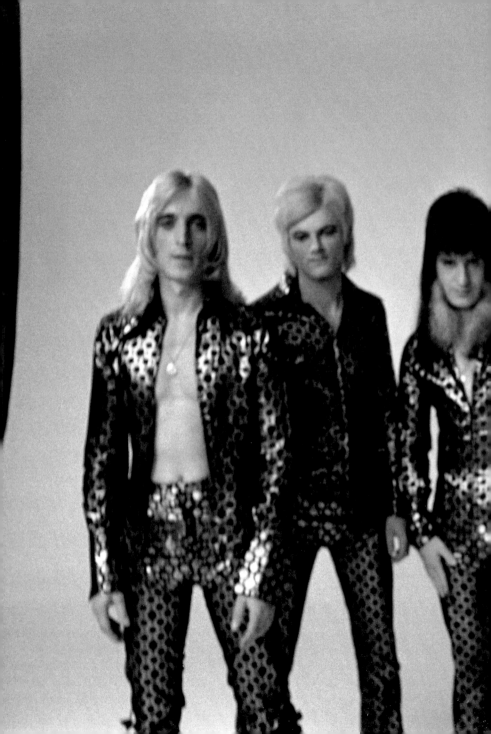

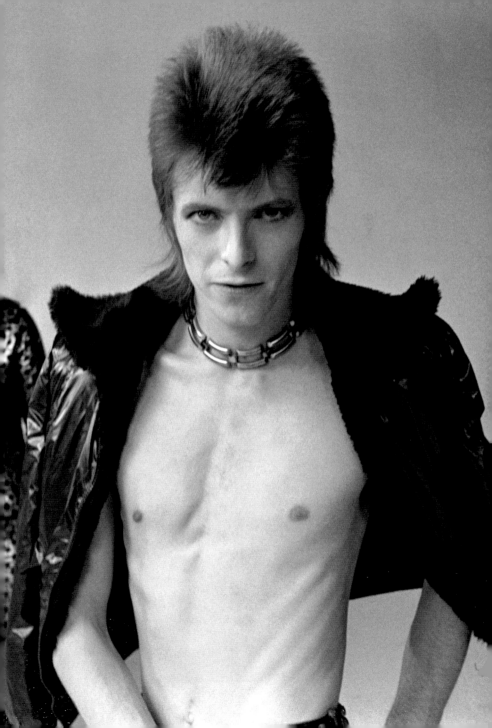

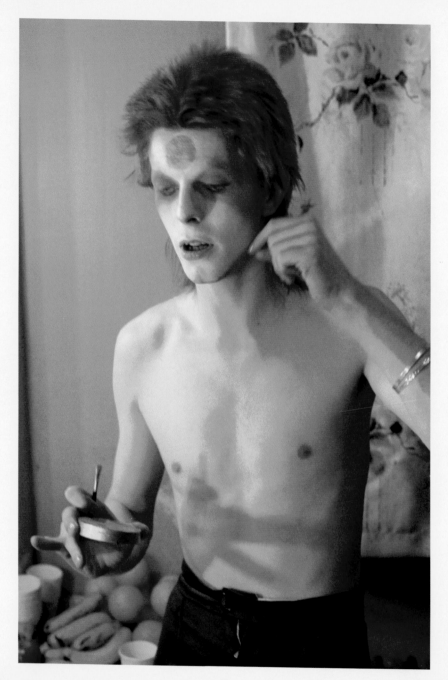

MICK ROCK

INTERVIEW BY BARNEY HOSKYNS

You couldn't make the name up: as the man himself says in the interview that follows, "Mick Rock" sounds like a cartoon character, a distillation of '70s pop culture in two onomatopoeic syllables. But Mick Rock is the real name of the photographer whose images captured and defined glam rock in the first half of that decade: the real name of the Cambridge graduate who, in the spring of 1972, documented the rise and rise of David Bowie in his brilliant incarnation as Ziggy Stardust.

He had made his cartoonish name with a striking album cover for former Pink Floyd frontman Syd Barrett — a personal hero of Bowie's — and Rock couldn't have been in a better place or time than the eye of the glam storm that swirled about Bowie in '72. The thrilling, outlandish and remarkably candid images in this book attest to the unparalleled access Rock had to the star who became, and remains, his friend. This kind of access and trust between photographer and star hails from another, more innocent era in rock music, when art was deemed far more important than commerce.

Could a photographer have been gifted with a more charismatic and iconic subject? Rock is self-effacing enough to admit the good fortune of the glam zeitgeist in which he found himself. But it was his images of Bowie — onstage, backstage, in the studio, off-duty at home or in transit — that fixed Ziggy Stardust at the epicentre of '70s pop and rock music.

Here, then, is Rock talking about his heady days with Bowie in the peak years of glam rock's teenage revolution.

"I THINK DAVID TRUSTED ME. I REGARDED MYSELF AS A GUARDIAN OF HIS IMAGE, AND THAT'S TRUE TO THIS DAY."

— MICK ROCK

Barney Hoskyns: What brought you and David Bowie together for the first time in early 1972?
Mick Rock: I was working in a darkroom at the offices of *Oz* magazine, and there was a pile of promo records with holes in the corners. Felix Dennis, who managed the magazine, said to me, "Help yourself". And there was *Hunky Dory*, so I took it home and played the life out of it — especially "Life on Mars?"

At the time, I was writing short pieces for *Rolling Stone* and illustrating them with photos. I'd been to Cambridge and could cobble together a few words. I had done a piece on Syd Barrett of Pink Floyd. I'd also done one on Rory Gallagher, whose first three album covers I shot.

When David said "I go both ways", it got people's attention. So I talked to Andrew Bailey — the London editor of *Rolling Stone* — and said, "What about Bowie?" He said, " Yeah, okay. He's been saying a few interesting things lately." At the same time, a friend of mine, the art director of *Club International*, said he wanted a music section at the front before you got to the boobies and bottoms — something a little provocative, I suppose. So that was commissioned too.

Anya Wilson, David's blonde publicist, met me at Liverpool Street station and took me up to a gig in Birmingham. She brought me backstage to introduce me to David, and he let me take the first pictures I ever shot of him. And then I took some performance shots during the show. A day or two later I went out to his house in Beckenham just outside London and interviewed him.

You once said that glam rock evolved out of the more flamboyant aspects of hippie fashion in the late '60s. Is it fair to say that even Syd Barrett slightly anticipated the androgyny of glam?
Well, David loved Syd, for a start. And in the most famous pictures of Syd — the ones from *The Madcap Laughs* album sessions — you can see he's got eye make-up on.

You have to remember that I was a student at Cambridge wearing bright bell-bottoms and long hair. The aspect of hippie-dom that appealed to many of us was the prettier side of it. Because that's where all the good-looking girls were! You've also got to remember David himself on the cover of *The Man Who Sold the World* in his Mr Fish medieval dress. That androgynous thing was very big in a certain strain of London hippie. Mickey Finn [later of T. Rex] was running about looking very flamboyant. Lots of velvet and lace. Not every hippie was grubby or wearing beards and beads.

Bowie has admitted that glam couldn't have happened without T. Rex's Marc

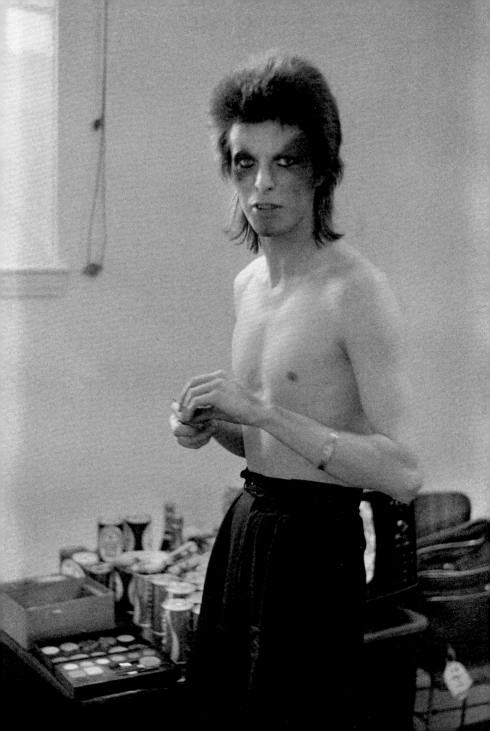

Bolan. The two of them later fell out. Do you remember why?

I don't remember David ever saying anything negative about Marc. To be honest, I don't remember him *talking* much about Marc at all. He was pretty self-consumed, and understandably so. But I think Marc had a rivalry thing about David. I mean, Marc was the king of the road there, certainly for most of 1971. He was the second coming of The Beatles in the UK media. And then Ziggy Stardust came along and Marc's star dimmed by comparison.

Should we think of Bowie as more of an avant-garde artist than a pop star?

David used to talk of himself as a Xerox machine, picking up impressions all over

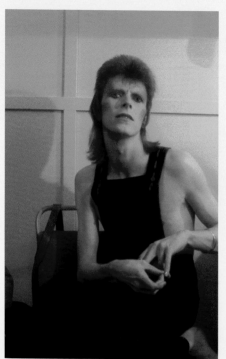

the place. He brought in a lot of elements: the Warhol thing, The Velvet Underground, Jacques Brel, kabuki, the Living Theatre, *A Clockwork Orange*. Lindsay Kemp was a huge influence. And of course the futuristic space thing, which Roxy Music got into as well. David absorbed things so fast. He made the concoction so rich and thick.

We know that Bowie took a great deal from his 1971 visit to New York, but it's interesting that in his foreword to your book *Glam! An Eyewitness Account* (2001), he sticks up for London: "We really did have our own drag queens and drugs, thank you very much…"

There were certainly drag queens and drugs, but it was a lighter and brighter *mélange*. There's no doubt that New York was darker, more depraved than London. I stayed on in New York after David's 1972 tour, and Lou Reed took me to places you'd never have found in London. As hip as I thought I was, in New York's underworld I was like an innocent abroad.

What David brought back from New York was the street-edge danger that was not in London, that was *absolutely* in New York. And that was what Marc never had — that edgy, sharp, truly bisexual aura that appealed to us more pretentious little buggers.

London was definitely prettier, and it really was less degenerate. Very naughty, but not really dark and wicked. There wasn't the sheer volume of amphetamine that there was in New York, and that was a major factor at Warhol's Factory and a major factor for Lou Reed. I never saw that much speed in London, but I saw tons in New York.

How did you start out as a photographer?

I was just playing around, really. The idea of

being a photographer didn't excite me nearly as much as the idea of being a whacked-out symbolist poet. If I hadn't shot Syd Barrett and got so excited about those pictures, my path might have been very different. By the autumn of 1969 I had a battered Pentax camera that I got from a mate for forty pounds. I still had literary aspirations, but I was enjoying the non-intellectual inner process that the camera was opening up for me. When people ask me what inspired me, it was really the charisma of a lot of my early subjects. It certainly wasn't other photographers.

What did you learn once you started shooting?

I learned early on not to get too hung up on technique: just get the bloody picture! A lot of my early film I processed myself, and a lot of it was grainy because of the low light levels I was working with. I never used a light meter: I just used to guess.

By the time I was doing studio work — like the Bowie saxophone session in 1973 — I'd acquired a Hasselblad and I was using Polaroid. I do remember Horst saying that he didn't understand modern photographers' obsession with all the technical stuff. He said, "I mostly work with one light and I just move it around till I see what I like." And that was kind of a validation of my own non-linear approach.

The key thing is that I wasn't inhibited at all. When young photographers ask me for advice, I normally just say, "Follow your obsessions."

Did Bowie critique your images of him? Did he have strong ideas about how he wanted to be photographed?

He seemed to like the photos I did from early on. He responded really well to the session I did at his home in Beckenham, the one that produced the now-iconic mirror shot. Every frame had a certain magic. On reviewing them he told his manager, "Mick sees me the way I see myself." Which I was delighted to hear, because it was important to me that he really liked them. I don't recall him ever telling me how to photograph him. The same with the videos we did: "Life on Mars?", "Space Oddity". "The Jean Genie" and "John, I'm Only Dancing". I learned a lot just watching and listening to him. And at the back of my mind always was the inspirational music that generated the creative energy, which whirled around him.

HE WAS OFF TO THE FUTURE AND HE WASN'T LOOKING BACK.

Presumably there has to be a good rapport between the photographer and his subject. Did that happen instantly between you and Bowie?

I think the thing with me in those early days was that a) I wasn't owned by anybody; b) I had no agenda, I wasn't like a smartass journalist; and c) I did interviews as well as take photographs. As a result, David and I got to know more about each other's thoughts and interests.

I remember going with David, Angie [Bowie] and my [then] wife Sheila to see a Joan Littlewood production. I can't remember what it was, maybe a revival of *Fings Ain't Wot They Used T'be*. David was already very knowledgeable about actors and directors, whereas I had no familiarity with the theatre scene. I also remember going down the Sombrero club in Kensington High Street with him. It was a very hip, predominantly

gay disco with a multicoloured Perspex dance floor — rich older queens and their young pickings, very exotic by the standards of the times. And then whenever he had a gig he'd invite me along.

At that first Birmingham gig there were only a few hundred people, but they were all very enthusiastic. And then I did some travelling with him on the first Ziggy tour of the UK, before the release of *The Rise and Fall of Ziggy Stardust and the Spiders from Mars*. It was the spring of 1972 and the audience kept growing and growing. I shot a bunch of stills and even some movie footage with a little windup 16 mm Bolex camera that had no sound. I used it to make a little film to promote the upcoming album, with "Moonage Daydream" as the soundtrack. No one knew who the hell I was, other than the cute name, but I was having so much fun.

What appealed to you about Bowie?
Initially I was inspired by his music, and then I was fascinated by his aura. I felt hypnotised by all the mutating and shifting around. In truth the persona interested me more than the personality, coupled with the naked ambition. It's all there in the *Ziggy* lyrics. He wasn't thinking about money, he was thinking about stardom. He was projecting powerfully. And of course when he made *Ziggy Stardust*, which is all about stardom, he was not a star. That was the record that *made* him a star.

You've got to remember how young we all were. I first met David forty-two years ago, when the world was a very different place. Psychologically it was a very impressionable time. What everyone now accepts as modern pop culture was brand new, and certainly my brain was wide open. Too much LSD and hatha yoga, no doubt!

On the back of *Ziggy Stardust* came Mott the Hoople's "All The Young Dudes", Lou Reed's *Transformer* and Iggy and the Stooges' *Raw Power*, all involving Bowie.
I remember sitting in a cab with David going through Hyde Park as he told me about Mott the Hoople. I think he'd hung out the night before with Overend Watts, Mott's bass player. The band had just been dropped by Island Records because dogs wouldn't piss on their first three albums. And he told me all about the song he was working on for them. When we got to his manager's office, he played the first few bars on an acoustic guitar: "All the young dudes carry the news..."

David rescued Mott and he rescued Lou Reed. His touch was magic. Lou was about to be dropped by RCA Records — which was David's label too — until David swooped in and produced *Transformer*. And it made Lou an international star.

David didn't really rescue Iggy Pop as such — although he certainly did a few years later. Iggy was way out in his own zone. But he facilitated *Raw Power* and did the original album mix. Now it's regarded as one of the greatest albums of all time, but as Iggy said to me a few years ago, "Three months after its release it was in the 50 cent bins."

1972 seems to have been the key year for glam.
It was the breakout year for so much of this. And of course you've got people like Amanda Lear, Lindsay Kemp, Bryan Ferry and Brian Eno all floating about. There were a lot of characters, even if they didn't necessarily know each other. David opened the door for Lou and Iggy and Mott, for starters.

The vibe of the American contingent — Lou and Iggy — was different, because

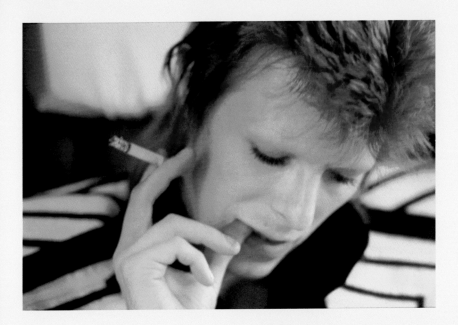

you knew they'd consumed a lot of heavy drugs. I have those pictures of David and Lou onstage at the Royal Festival Hall for David's Save the Whales charity concert in July 1972, and Lou's all dressed in black and David's all dressed in white. I always see a certain symbolism in that. Lou was dark and New York, and David was light and London. That magical synergy between London and New York was what it was all about for me.

The access you had was remarkable — the fact that Bowie allowed you to shoot him getting undressed backstage. We're rarely allowed to see such informality these days.

I think David trusted me. I regarded myself as a guardian of his image, and that's true to this day. My respect for him was, and remains, profound. I got all those pictures of him hanging about looking very exotic in very mundane situations. I got pictures of him eating, drinking coffee, having a cigarette before going onstage, making himself up. I even got shots of him *asleep*. And there's that famous picture that everyone loves of him and Mick Ronson having lunch on the train to Aberdeen.

That image really sums up Britain in the early glam rock era: even Ziggy Stardust has to eat a British Rail lunch!

People love that shot. It's turned out to be a very popular print, possibly my *most* popular. Other photographers who shot David or Lou or Iggy were one-offs. But I was all over it, not just the musicians but *The Rocky Horror Show*, Lindsay Kemp, the Biba store, Andrew Logan's *Alternative Miss World*, Bill Gibb, Zandra Rhodes, Pierre La Roche. Slowly I was becoming "Mick Rock", whoever *he* was. The name sounded like a cartoon!

I guess there's so much more you can do with visually charismatic stars, as opposed to just shooting A. N. Other rock band in denim jeans.

I have a tape of an interview I did with David around the release of "Starman", just before the release of *Ziggy Stardust*. He said something about wanting rock 'n' roll to be in "blazing technicolour". He was fed up with all the boring scruffy denim stuff. He was off to the future and he wasn't looking back.

When they invited me to the Victoria and Albert Museum for the special preview of the Bowie show in 2013, I wandered around and felt flabbergasted by a) how much David had kept in his archive and b) the sheer variety of what was there. I'd always kept my eyes and ears on what David was up to over the years, but to absorb it all in one gulp was an unbelievable experience.

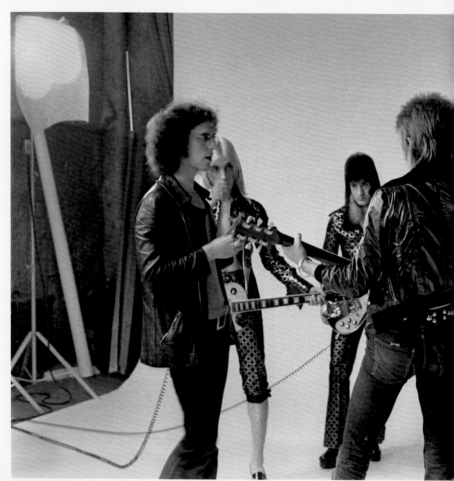

How much outrage did you actually experience with Bowie? Was there a genuine sense of disgust from the very people who were watching the famous British female impersonator Danny La Rue on TV every Saturday night?

But you see, Danny La Rue was still old school, that music-hall tradition of men dressing up in drag. It wasn't threatening — my *grandmother* was a Danny La Rue fan. Whereas David was threatening,

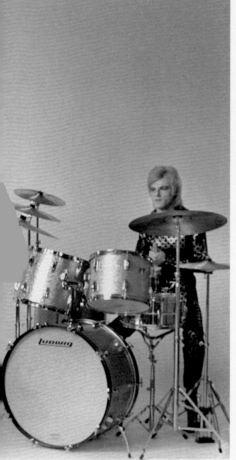

because it was a different consciousness. No matter what you want to call it — the feminisation of the male or whatever it was — androgyny *was* a threat.

When you travelled with David, there was a decent amount of "You fuckin' poof!" But you get into a kind of pocket where you're all in it together and enjoying the abuse. It was *épater la bourgeoisie*. It felt revolutionary. The more you disapproved, the more we loved it. I thought David was a very brave soul. I still do.

As Ziggy, Bowie went way beyond androgyny, partly because he was so very ectomorphic.

Well, none of us had much flesh on us. I'm six foot one inch and I weighed ten stone at the time. David did actually eat reasonably regularly, but he burned it all up with his non-stop activity. There was a core of him that was very strong, even when he wasn't eating very much. What gave him his power were his very powerful thighs and a neck that was very long but also very strong.

How did you experience the changes from *Ziggy* to *Aladdin Sane*?

David *kept* changing. Think of the pictures of him in America in the high heels and with Cyrinda Foxe, the famous limp-wrist shot with the earrings and so on. Even by the summer of '72 in England he was wearing that little plastic James Dean jacket. He was always mutating, right up to *The Midnight Special* at the Marquee in the autumn of '73.

Although it looked revolutionary, the early Ziggy stuff in the Freddie Burretti era still wasn't the exotic thing that he became — especially after David went to Japan and bagged a bunch of costumes from Kansai Yamamoto for the *Aladdin Sane* period, which was really Ziggy Mark 2.

When Bowie announced to Michael Watts in *Melody Maker* that he was gay and always had been, you presumably knew that wasn't entirely true.
Well, he had his eye on my sister-in-law Bambi much more than he ever did on me — let's just leave it at that. I never caught David *in flagrante delicto*. If you don't witness it, how can you ever know? The rest is chit-chat and gossip.

Forty years later, with sports stars finally beginning to stick their heads out of the closet, it seems braver than ever to have simulated gay fellatio onstage in June 1972.
David always said that it was the way Mick swung his guitar that forced him to go down. You can see that he's not really on his knees. His feet are splayed. He was initially just trying to bite Mick's guitar. Of course he would duplicate that on many occasions, just as he would *duplicate* Mick straddling him. But that all came out of the reaction he got at Oxford Town Hall. He knew he'd done something very provocative. He knew he'd made a statement. Suddenly a thousand people were showing up at his gigs. It was certainly the music but it was also the titillating publicity.

How did it wind down for you with Bowie?
I was starting to develop my own identity, and I went off on my own tangent. I didn't want to just be David's personal photographer. I loved him and his extraordinary talents, but his shadow was overpowering — you could get lost in it. In spite of all my spaced-out-ness, there was a certain innate ambition in me. I was a Cambridge scholar, after all, and there had always been heavy expectations of me when I was growing up.

I spent a lot of time with Lou Reed in the '70s, but then to my mind Lou was the new Baudelaire, simple as that. Plus there was my ardent love affair with New York. I always wanted to work more with David — and I did do a terrific session with him in 2002 — but my life went completely off the rails for a number of years and somehow it never worked out. I'm just delighted that through all the lunacy of the '70s and '80s, I kept my negatives and chromes.

Isn't it interesting how glam keeps coming and going — and then coming back again?
The glam-punk fusion is with us all the time, and has been for a long time now in fashion. People love that synergy. Some of it edges more towards punk, some more towards glam. You'd be amazed at the number of fashion designers who tell me how much my images influenced them. Somehow they keep getting recycled. I'm certainly not complaining at this late stage of the game. They provide fertile fodder for my maturity: books, exhibitions, museums, endorsements and so forth. Plus I'm still working, still shooting. I recently shot the Yeah Yeah Yeahs, Snoop Dogg, Janelle Monáe — to name just a few.

I owe so much to the '70s, even though for years I tried to run from it. It's the foundation of my reputation and I've learned to embrace it.

22 Oxford New Theatre, 26 June 1973.
25 Backstage before the show at Aberdeen Music Hall, Scotland, 16 May 1973.
26 Backstage at Caird Hall, Dundee, Scotland, 17 May 1973.
29 Taking the train from London to Aberdeen, 14 May 1973.
30–31 Shooting "The Jean Genie" promo, San Francisco, 27 October 1972.
33 On the luxury liner *QE2*, Southampton, January 1973.

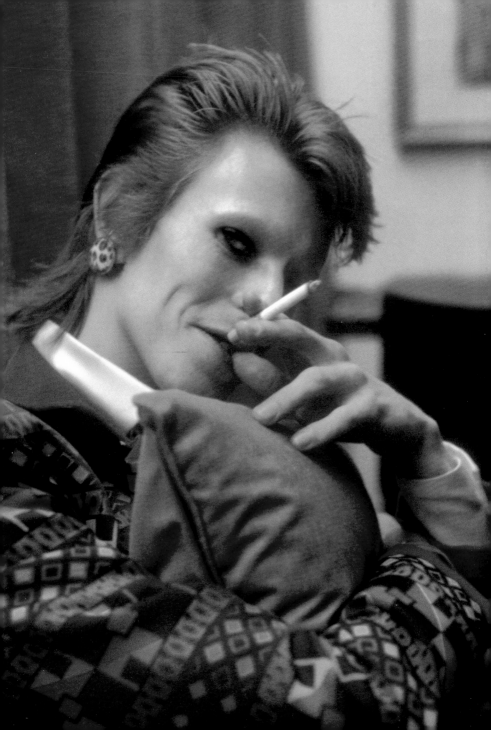

FIVE
YEARS

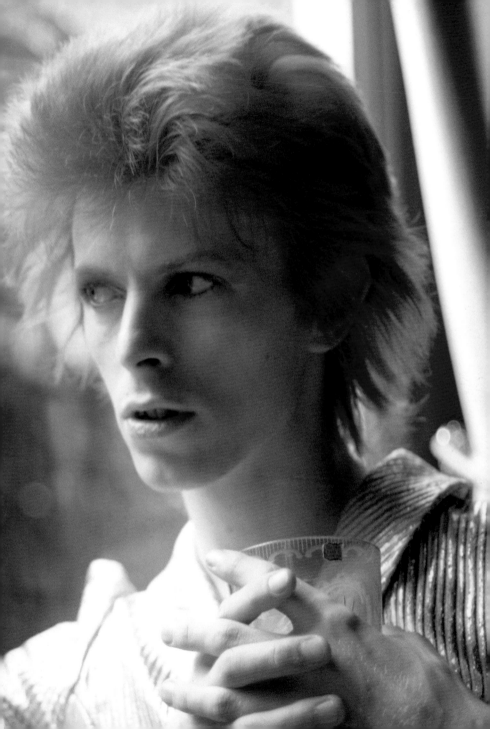

"WE'VE GOT FIVE YEARS,
WHAT A SURPRISE
WE'VE GOT FIVE YEARS,
STUCK ON MY EYES
WE'VE GOT FIVE YEARS,
MY BRAIN HURTS A LOT
FIVE YEARS,
THAT'S ALL WE'VE GOT."

34–35 Haddon Hall, Beckenham, March 1972.
A shot using natural daylight streaming in through the
big windows, Rock's favourite type of lighting.

Haddon Hall, Beckenham, March 1972.
In the autumn of 1972, it was used on the front cover of
the US re-release of the 1969 album *Space Oddity*.

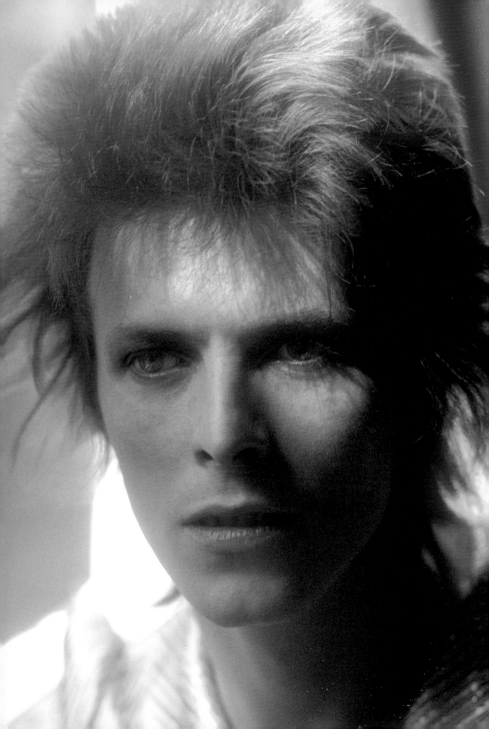

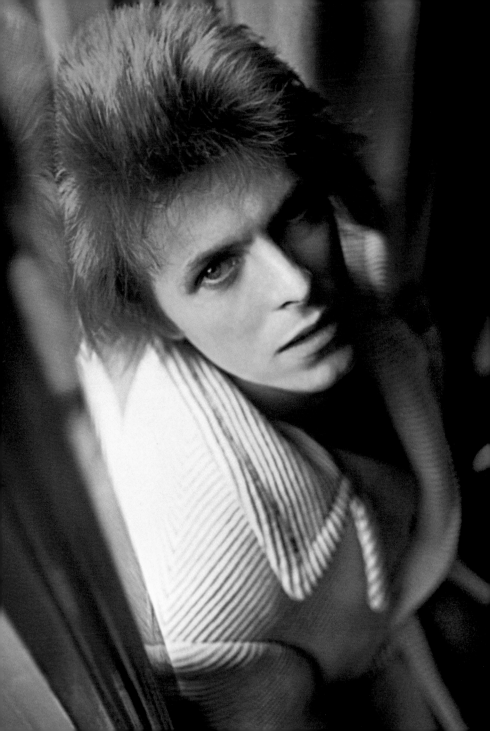

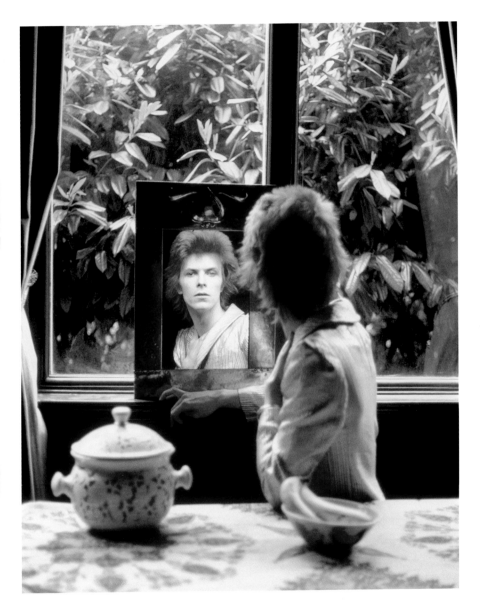

Haddon Hall, Beckenham, March 1972.
Note the bananas in the foreground of the mirror shot: a favourite snack of Bowie's.

40–41 Trident Studios, London, August 1972.

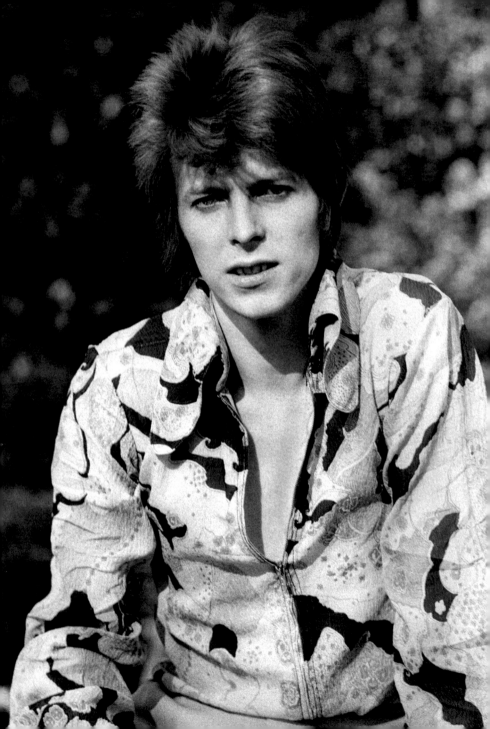

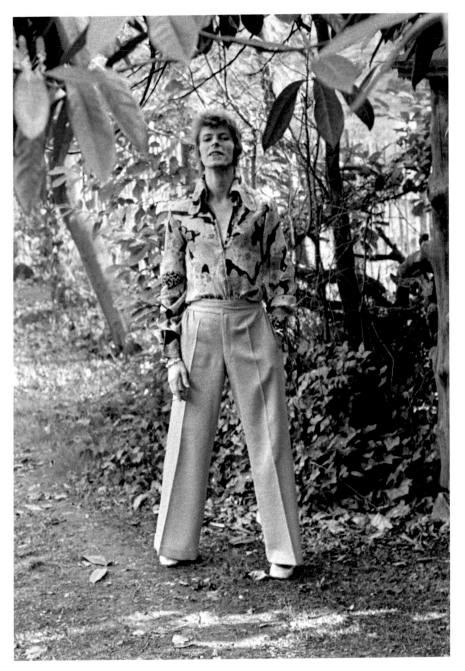

"DAVID WAS FED UP WITH ALL THE BORING SCRUFFY DENIM STUFF."

— MICK ROCK

42–43 Haddon Hall, Beckenham, early March 1972.

Rock did the photo session to accompany an interview he wrote up for *Rolling Stone* magazine.
Haddon Hall, Beckenham, late March 1972.

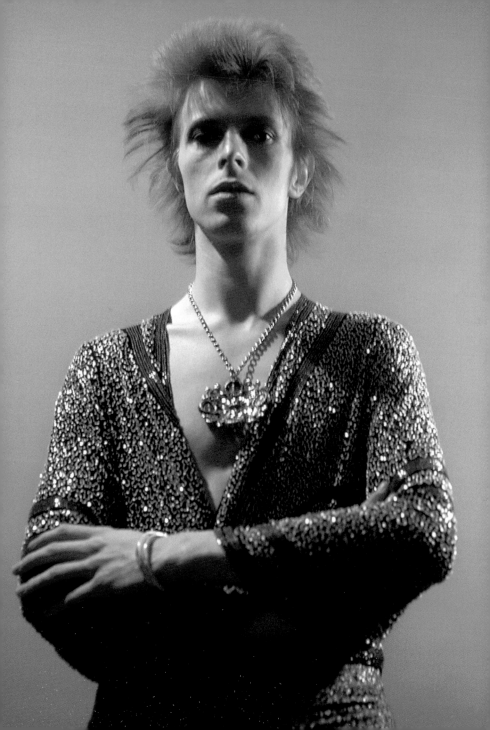

SOUL
LOVE

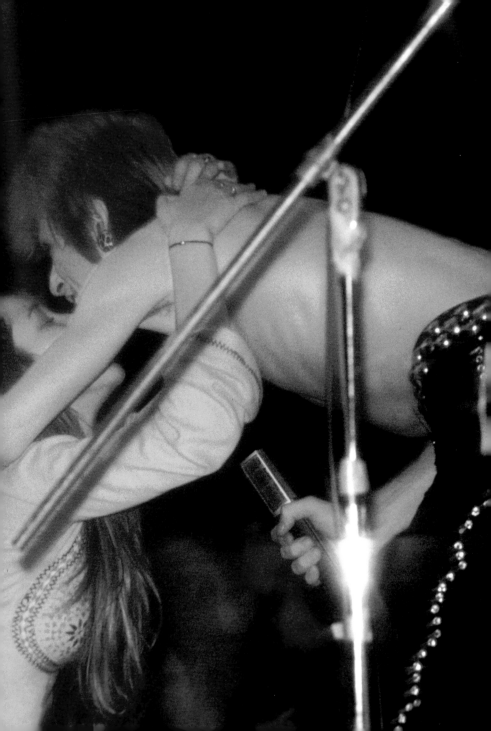

"INSPIRATIONS HAVE I NONE
JUST TO TOUCH THE FLAMING DOVE
ALL I HAVE IS MY LOVE OF LOVE
AND LOVE IS NOT LOVING."

46–47 Brighton Dome, England, 23 May 1972.
49–51 Southampton Guildhall, Summer tour, 18 June 1973.

48

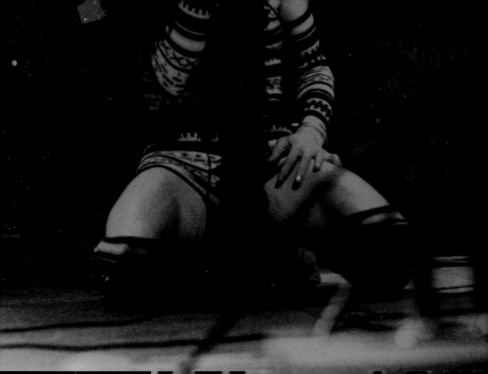

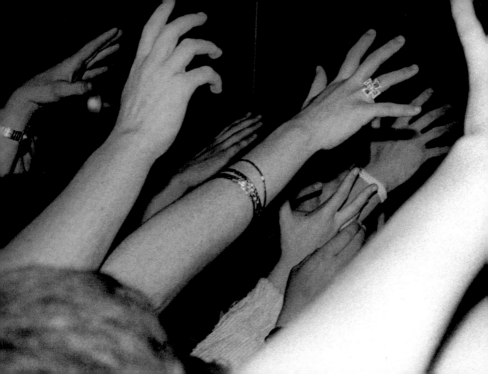

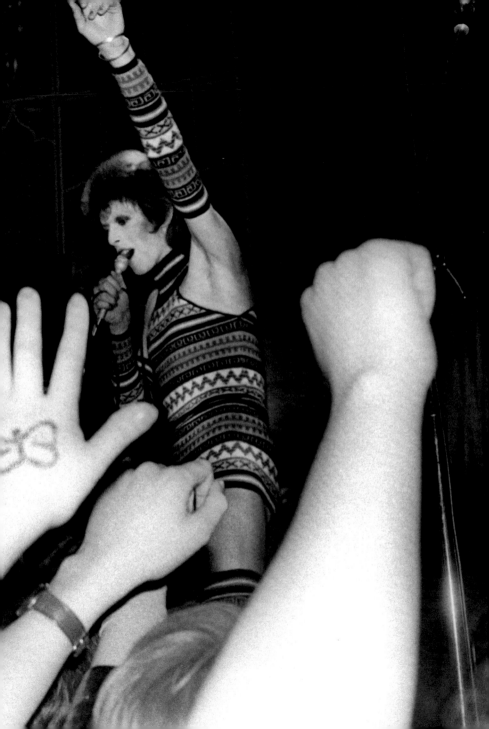

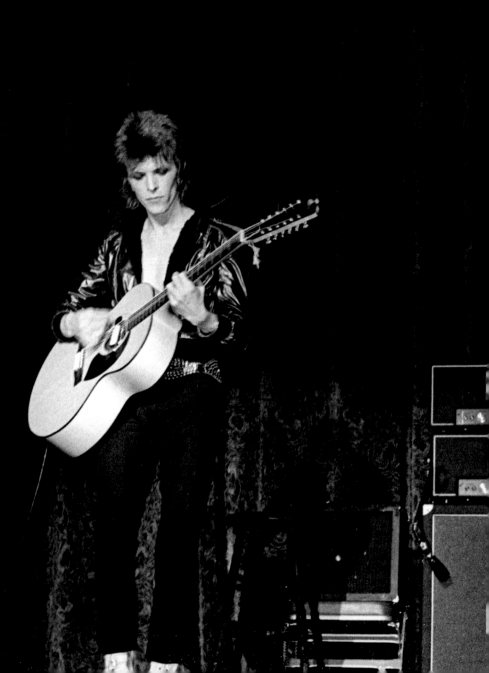

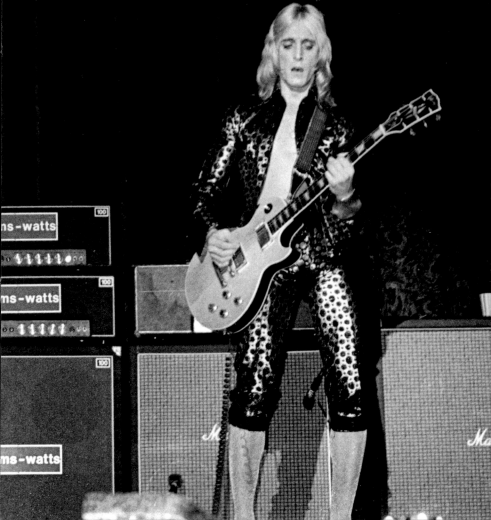

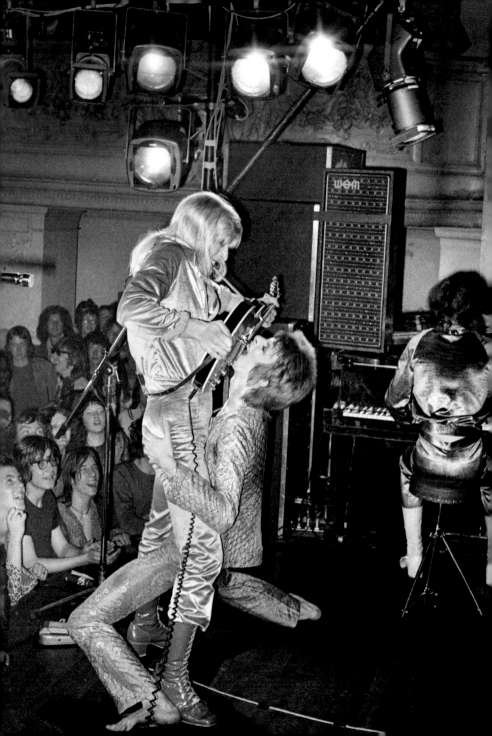

"DAVID ALWAYS SAID IT WAS THE WAY MICK SWUNG HIS GUITAR THAT FORCED HIM TO GO DOWN. YOU CAN SEE THAT HE'S NOT REALLY ON HIS KNEES. HE WAS INITIALLY JUST TRYING TO BITE MICK'S GUITAR..."

— MICK ROCK

52–53 Santa Monica Civic Auditorium, 20 October 1972.

Oxford Town Hall, England, 17 June 1972.
This photo created a buzz of controversy when it was published in *Melody Maker* on 20 June.

56–57 UK Summer tour, May–July 1973.

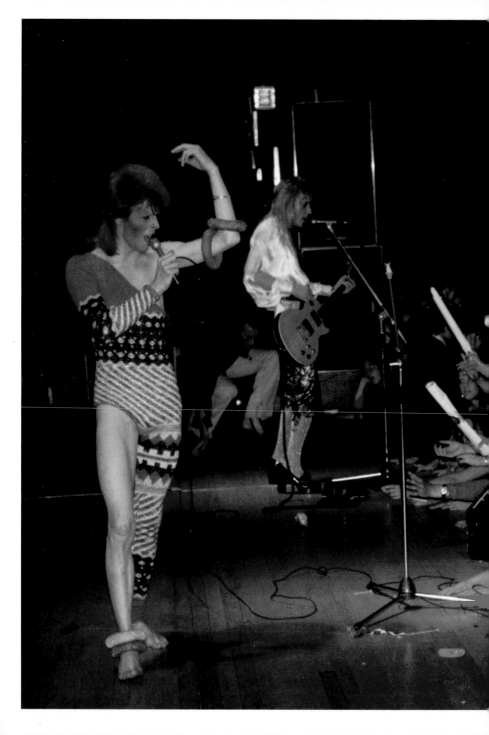

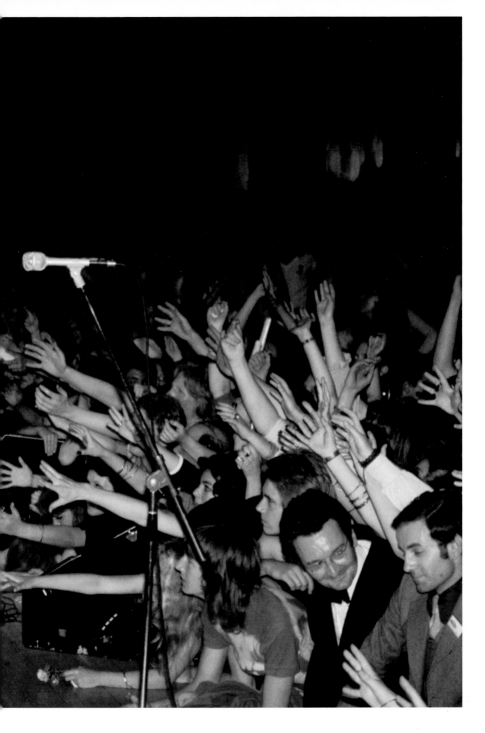

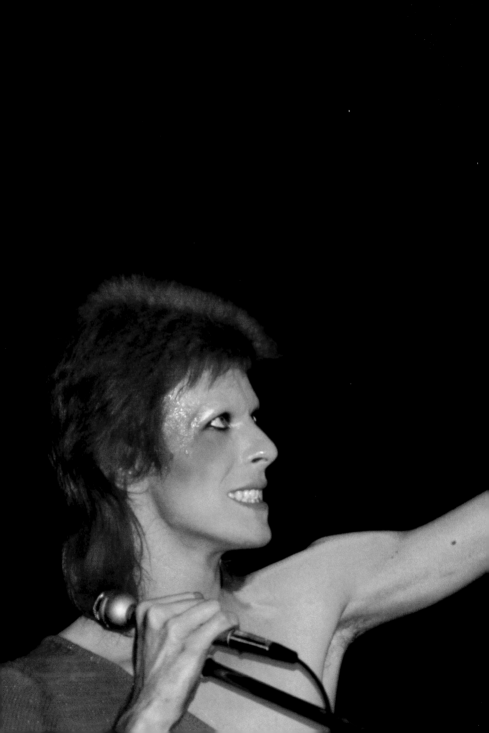

MOON AGE DAY DREAM

"I'M AN ALLIGATOR,
I'M A MAMA–PAPA COMING FOR YOU
I'M A SPACE INVADER,
I'LL BE A ROCK 'N' ROLLIN' BITCH FOR YOU."

58–59 Summer tour, May–July 1973.
"The Retirement Gig", Hammersmith Odeon, London, 3 July 1973.

60

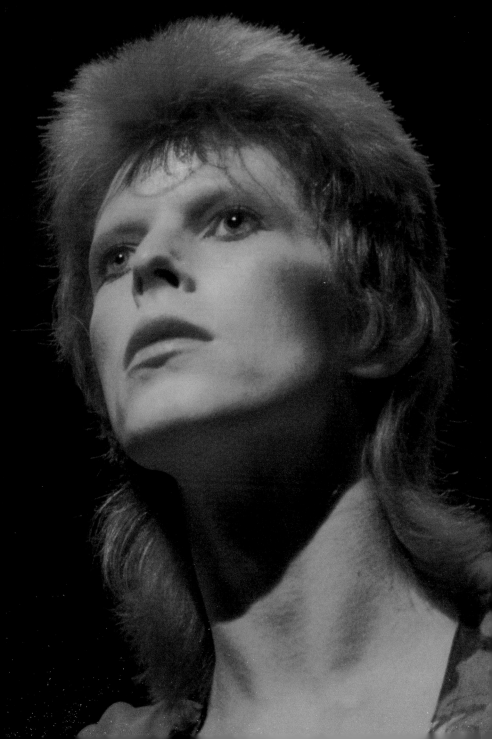

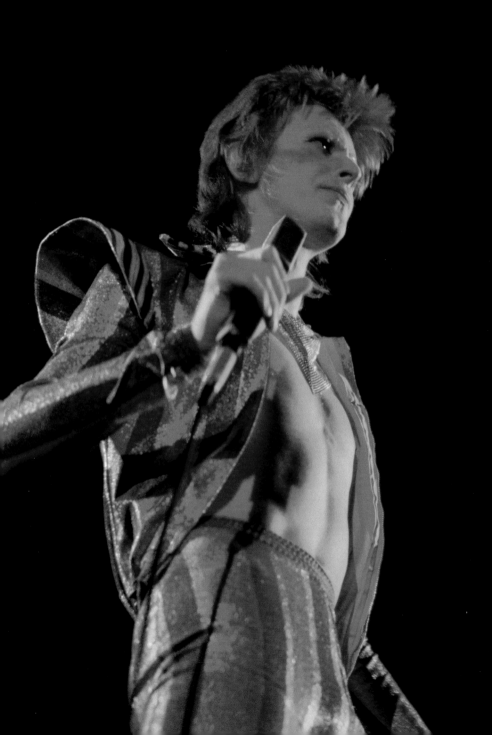

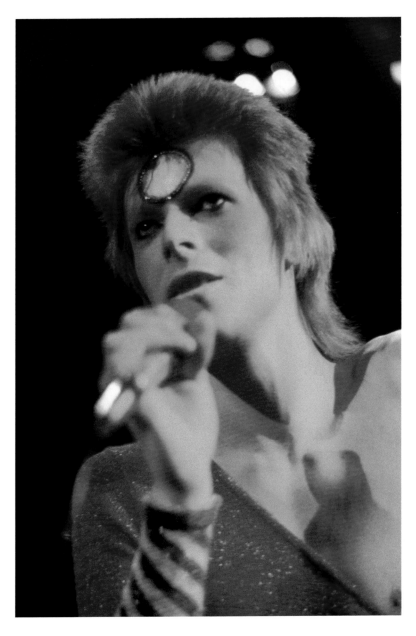

Fairfield Halls, Croydon, England, 24 June 1973. UK Summer tour, May–July 1973.
64–65 Santa Monica Civic Auditorium, 21 October 1972.

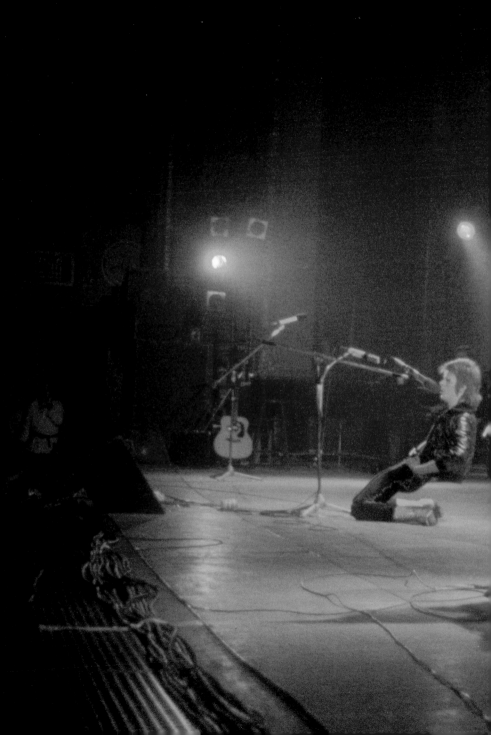

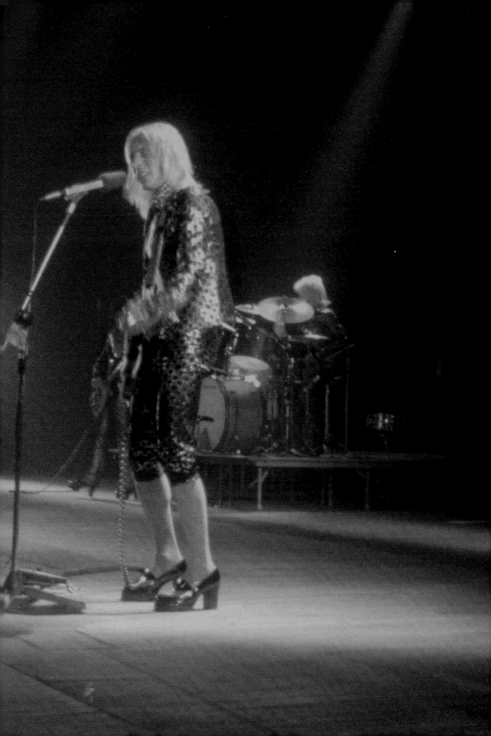

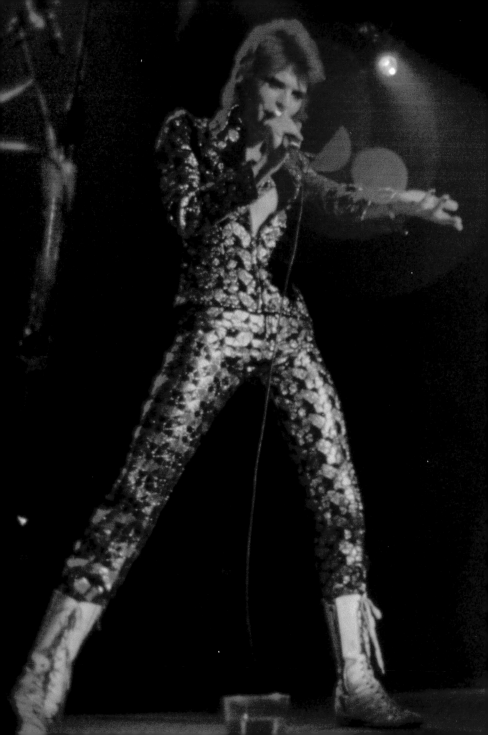

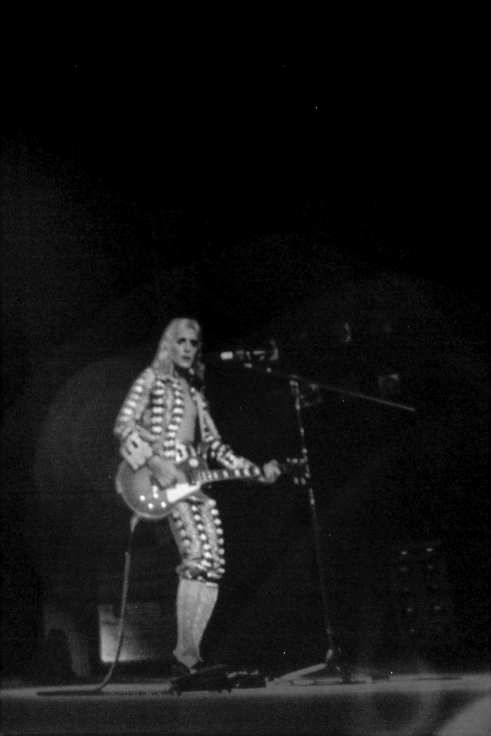

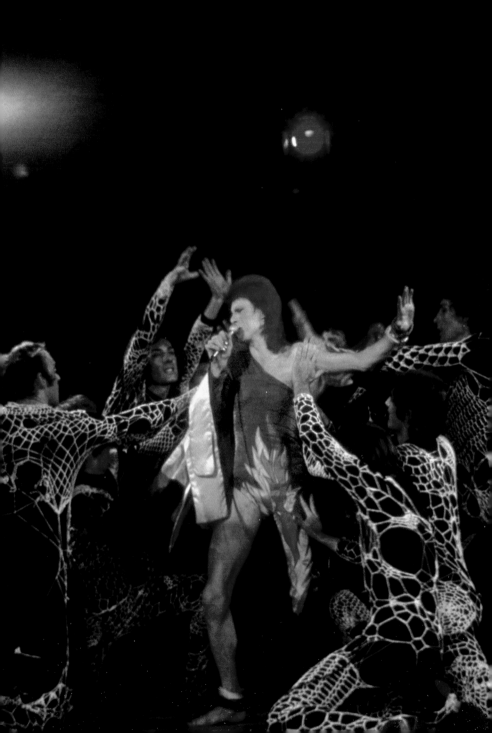

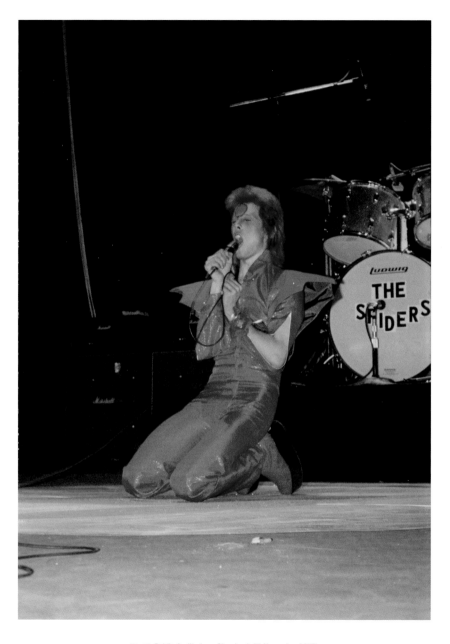

66–67 Public Auditorium, Cleveland, 25 November 1972.
1980 Floor Show, 18–20 October 1973, Marquee Club, London. UK Summer tour, May–July 1973.

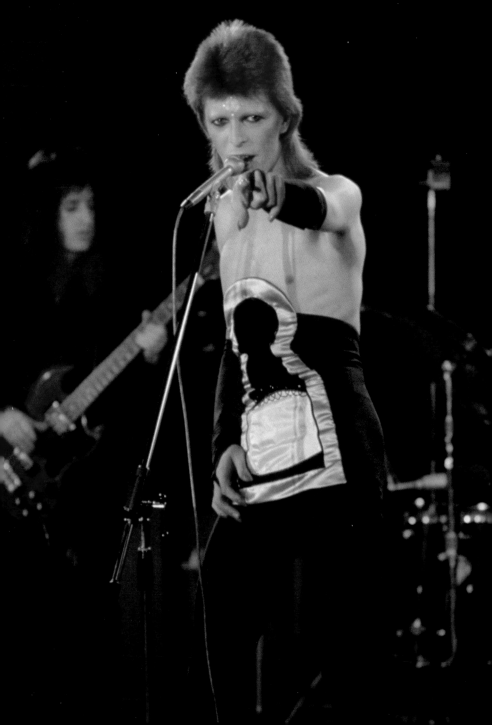

"IT WAS *ÉPATER LA BOURGEOISIE.*
IT FELT REVOLUTIONARY.
THE MORE YOU DISAPPROVED,
THE MORE WE LOVED IT . . ."

— MICK ROCK

1980 Floor Show, 18–20 October 1973,
Marquee Club, London.

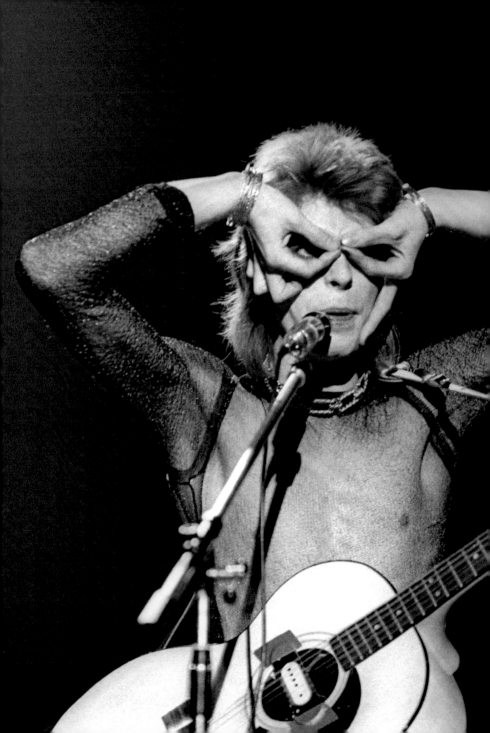

"THERE'S A STARMAN WAITING IN THE SKY
HE'D LIKE TO COME AND MEET US
BUT HE THINKS HE'D BLOW OUR MINDS."

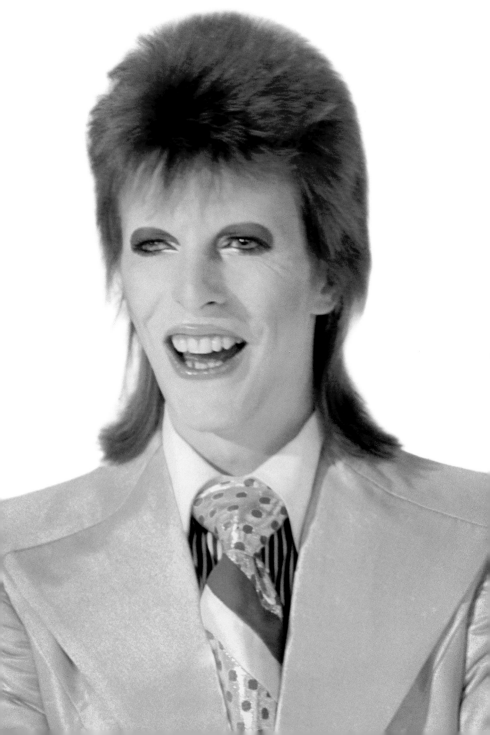

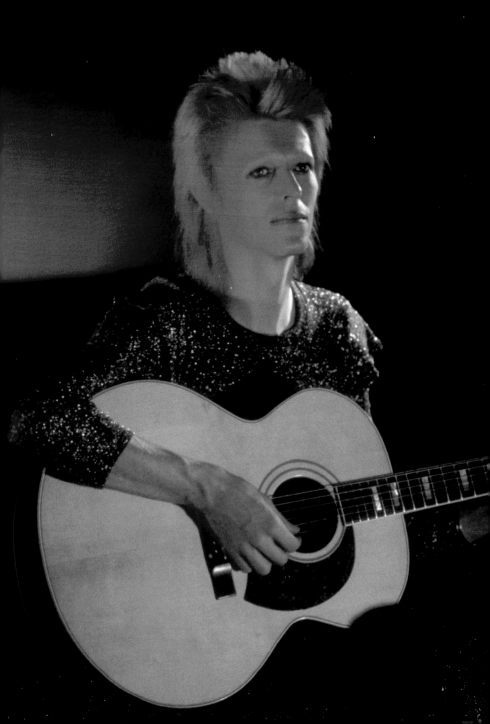

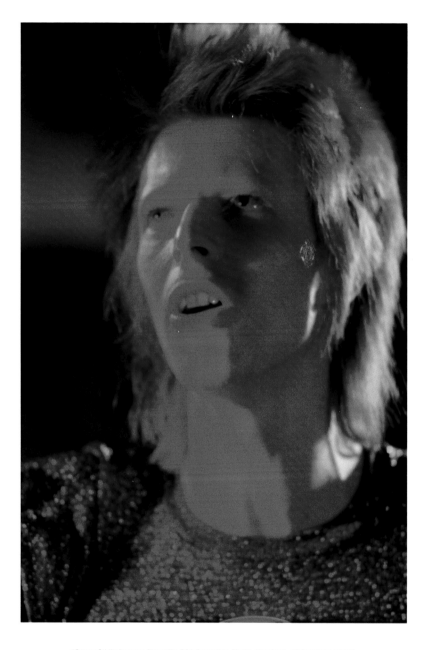

"Space Oddity" promo film stills, RCA Recording Studio, New York, 10 December 1972.
Rock shot him from 10 a.m. to 3 p.m. and afterwards Bowie left the studio to catch the boat back to London.

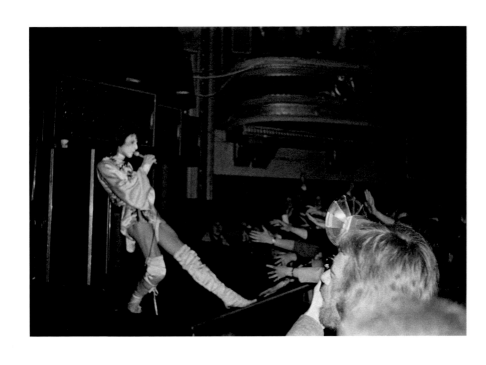

Aberdeen Music Hall, 16 May 1973. UK Summer tour, May–July 1973.

80–81 The Gaumont Theatre, Worcester, England, 4 June 1973.

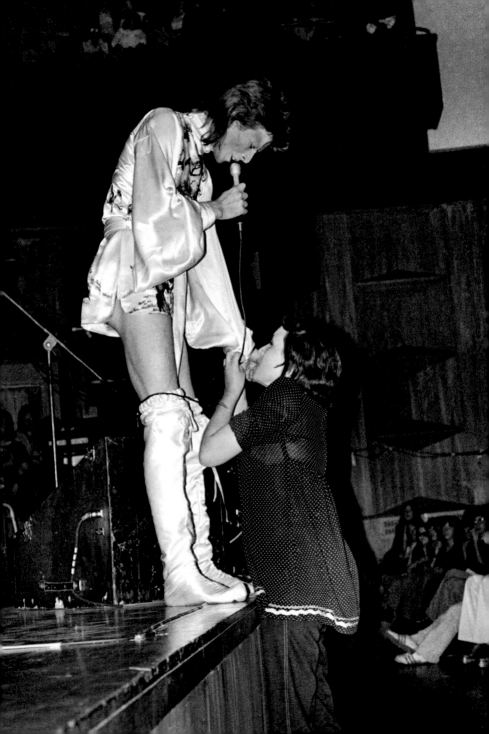

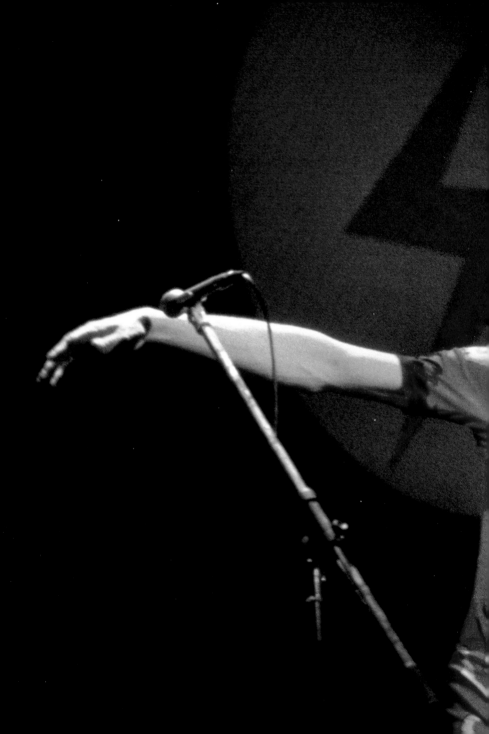

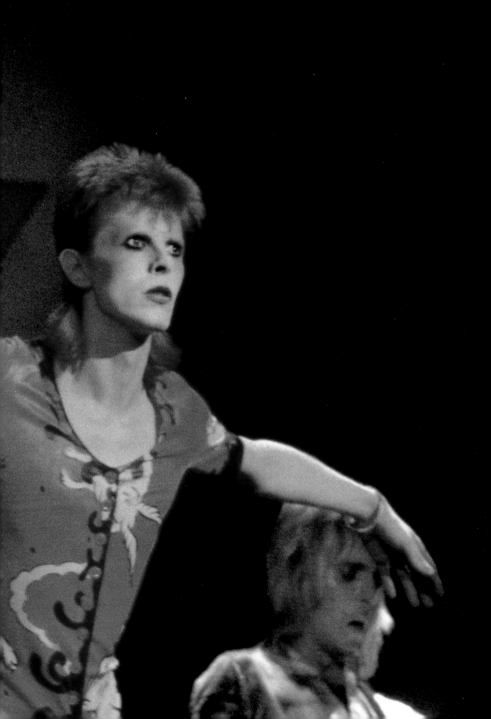

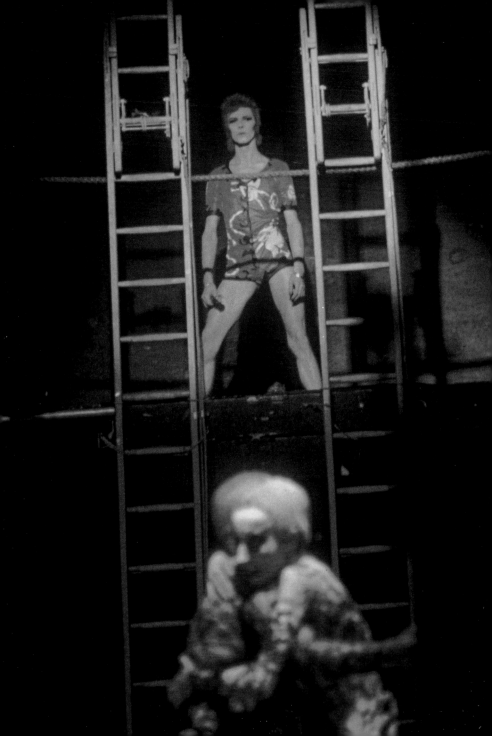

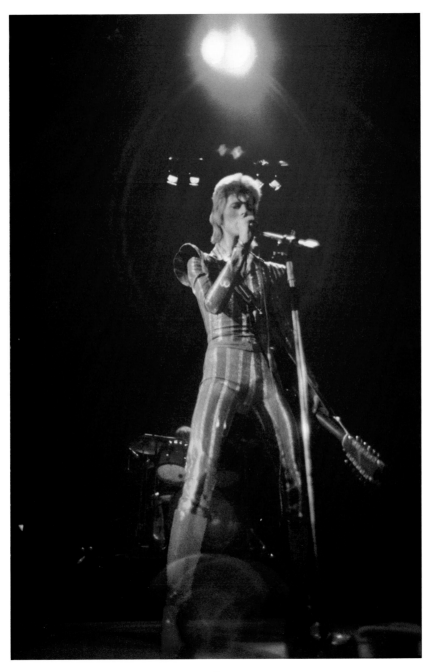

"AT THAT FIRST BIRMINGHAM GIG
THERE WERE ONLY A FEW
HUNDRED PEOPLE, BUT THEY WERE
ALL VERY ENTHUSIASTIC..."
— MICK ROCK

82 Rainbow Theatre, London, 19–20 August 1972.

83 UK Summer tour, May–July 1973.

Green's Playhouse, Glasgow, 18 May 1973.

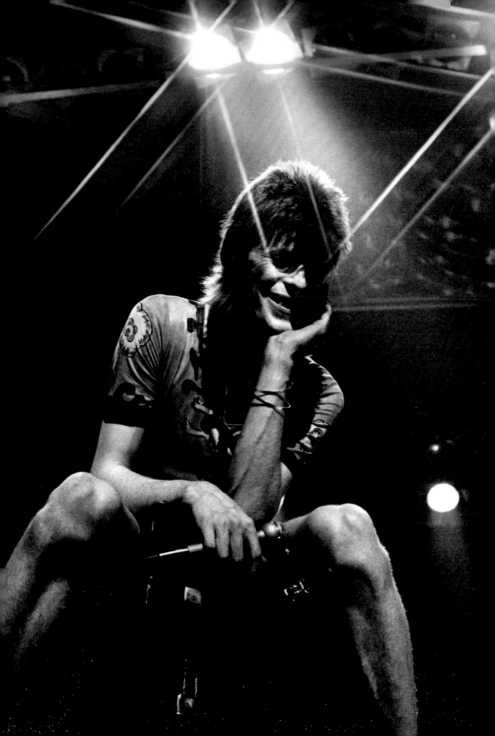

IT
AIN'T
EASY

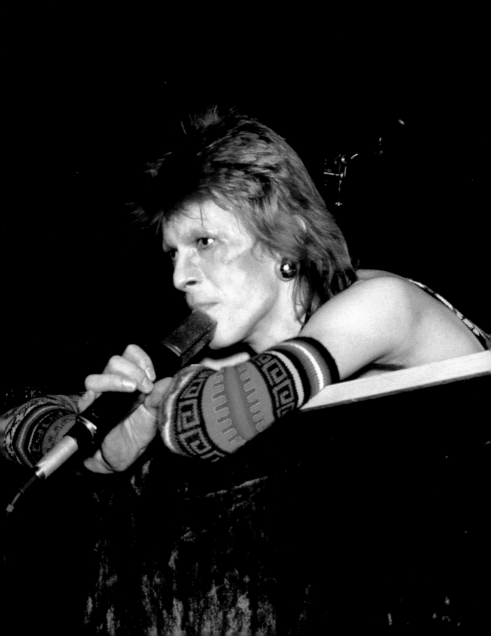

"WE CAN ALL PULL ON THROUGH
GET THERE IN THE END
SOMETIMES IT'LL TAKE YOU RIGHT UP
AND SOMETIMES DOWN AGAIN."

86–89 UK Summer tour,
May–July 1973.

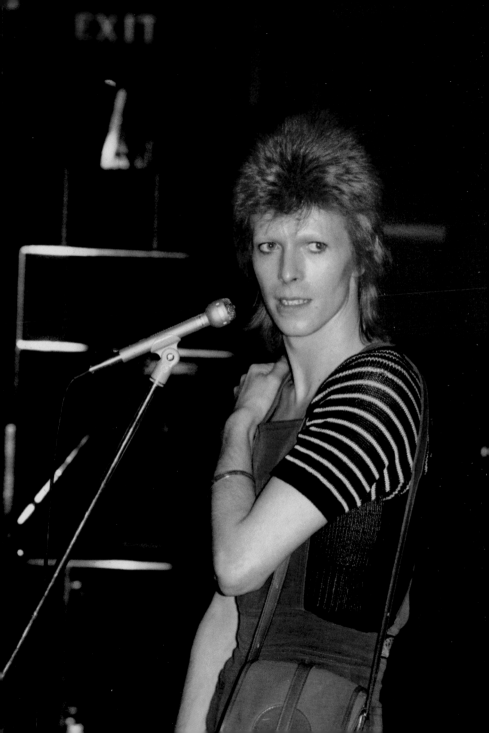

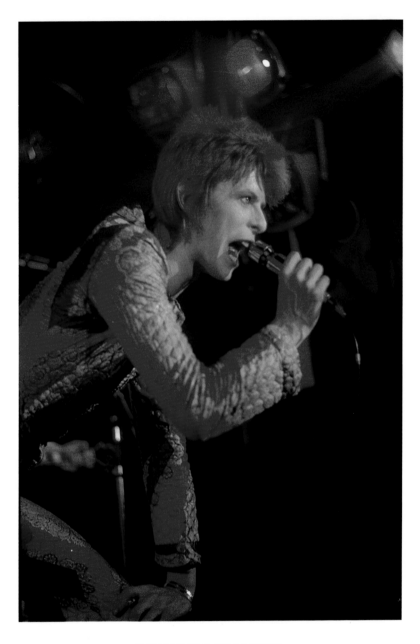

Hammersmith Odeon, London, 2 July 1973.
Dunstable Civic Hall, England, 21 June 1972.

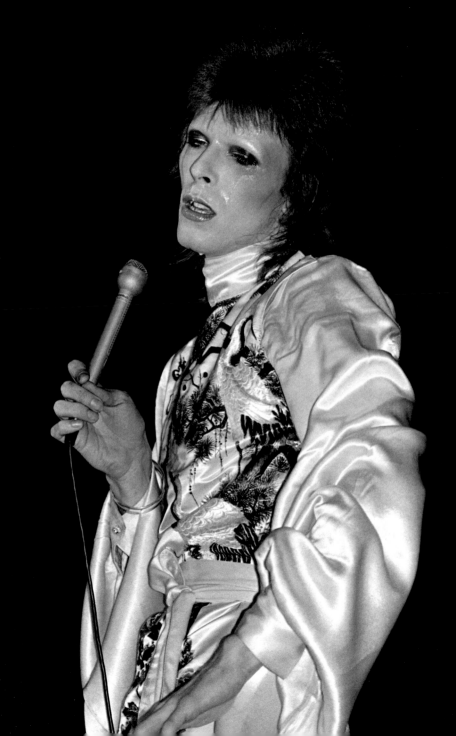

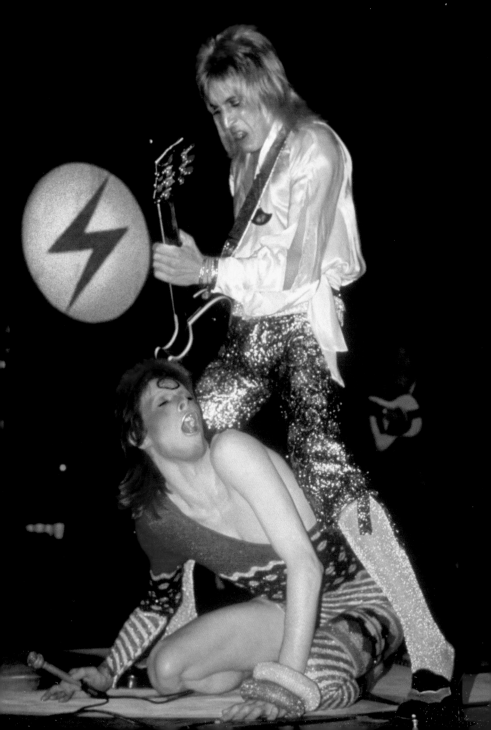

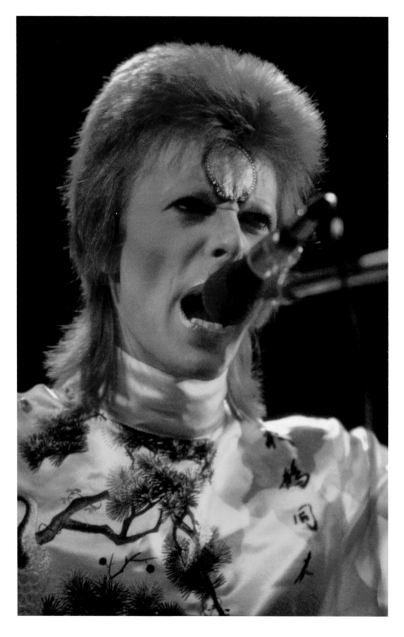

Earls Court, London, 12 May 1973. Empire Theatre, Liverpool, England, 10 October 1973.
94–95 Fairfield Halls, Croydon, 24 June 1973.

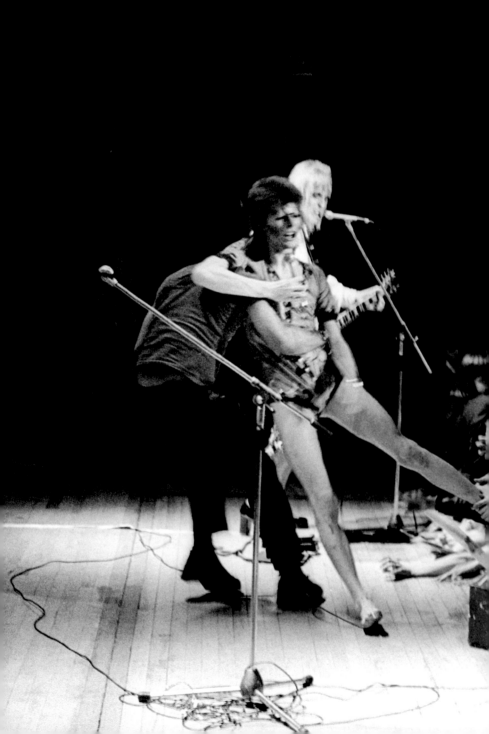

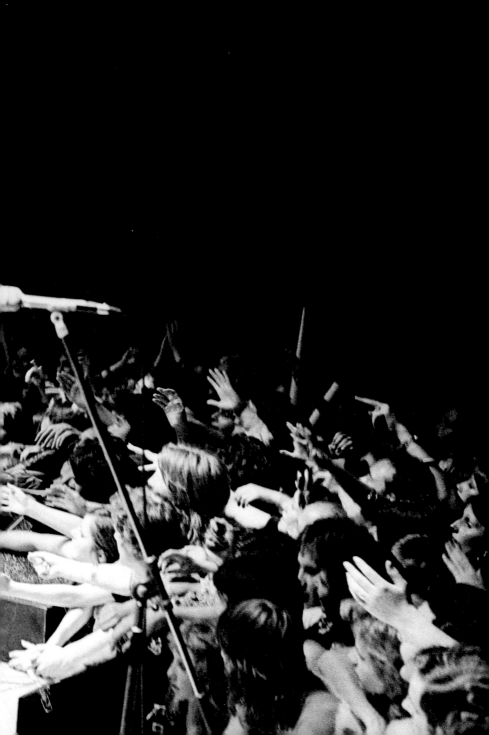

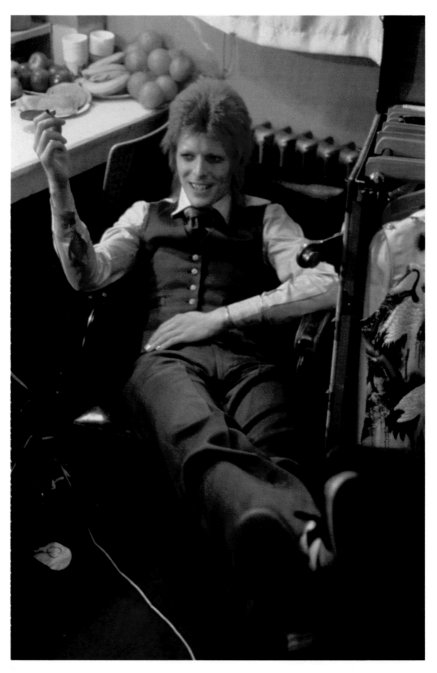

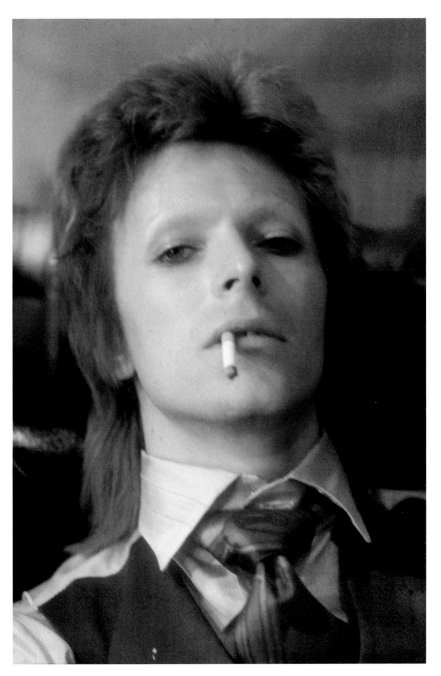

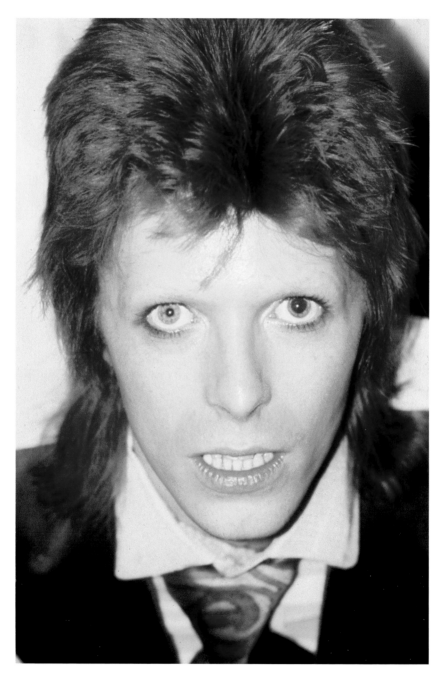

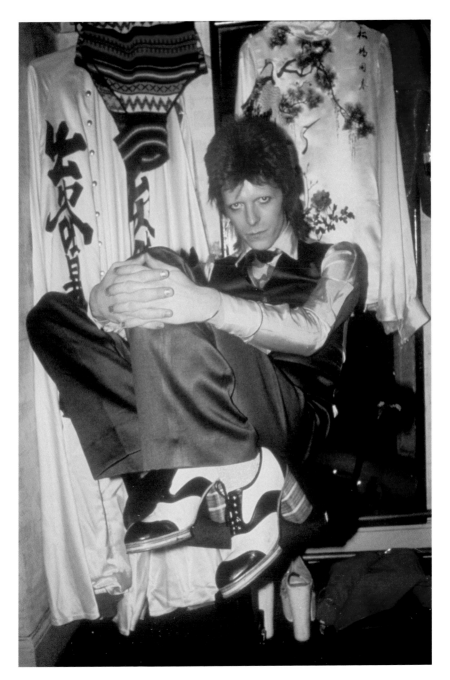

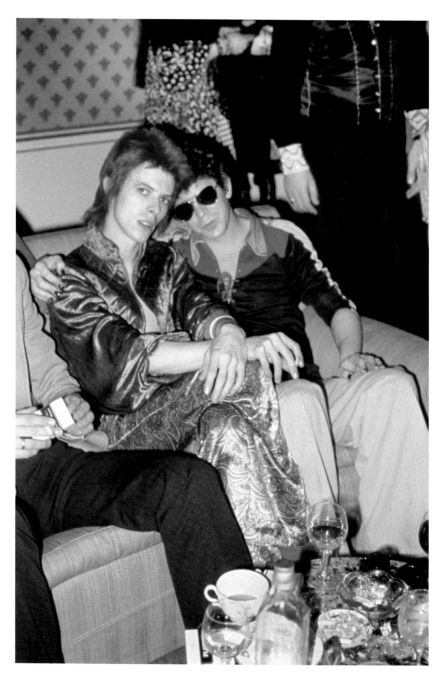

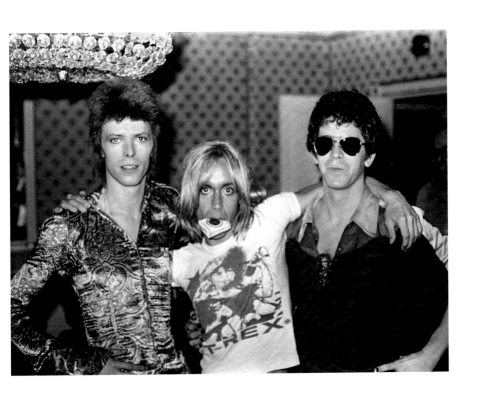

96–99 UK Summer tour, May–July 1973.
Bowie and Lou Reed, Dorchester Hotel, London, 16 July 1972.
Bowie, Iggy and Lou Reed, Dorchester Hotel, London, 16 July 1972.
102–103 Café Royal, Piccadilly, London, 3 July 1973.
After-party, often called "The Last Supper", for Bowie's final
Ziggy concert at the Hammersmith Odeon.

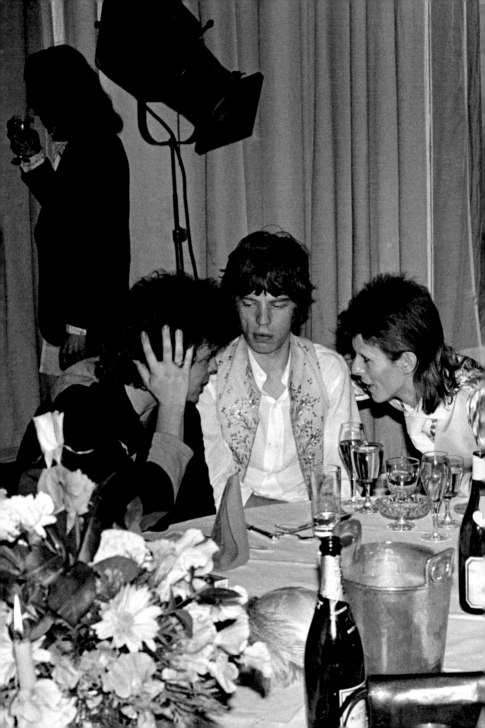

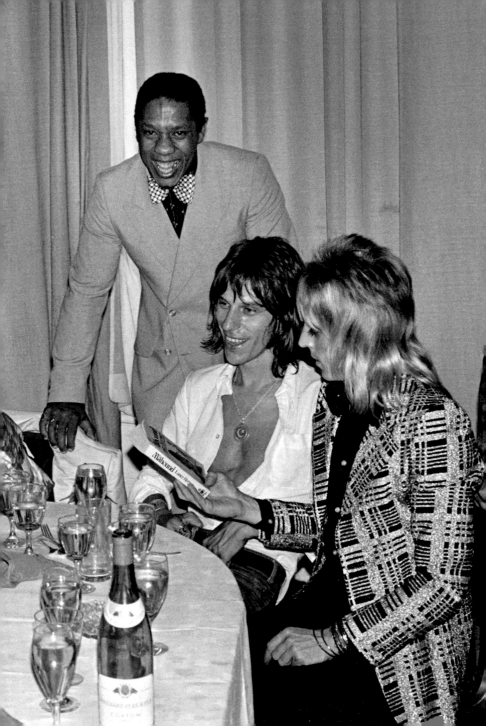

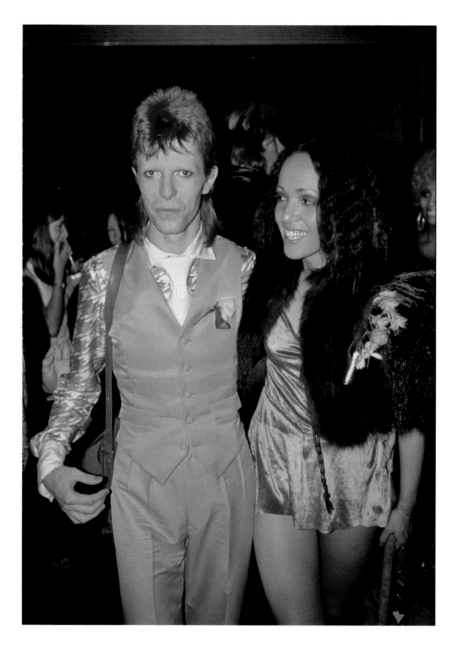

Bowie with Jean Millington of the all-girl US band Fanny,
Café Royal party, 3 July 1973.

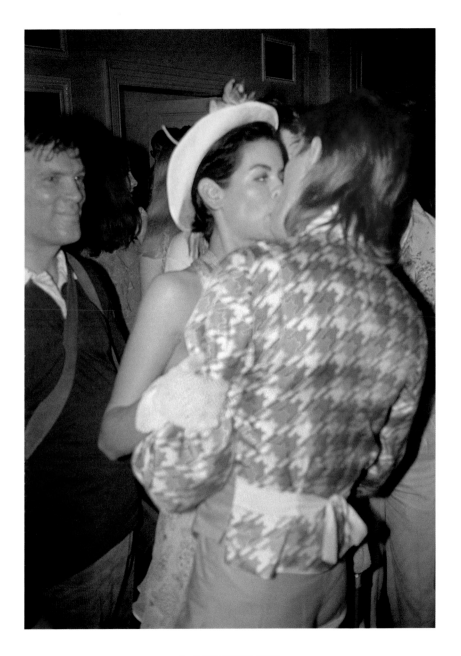

Bowie kissing Bianca Jagger,
Café Royal party, 3 July 1973.

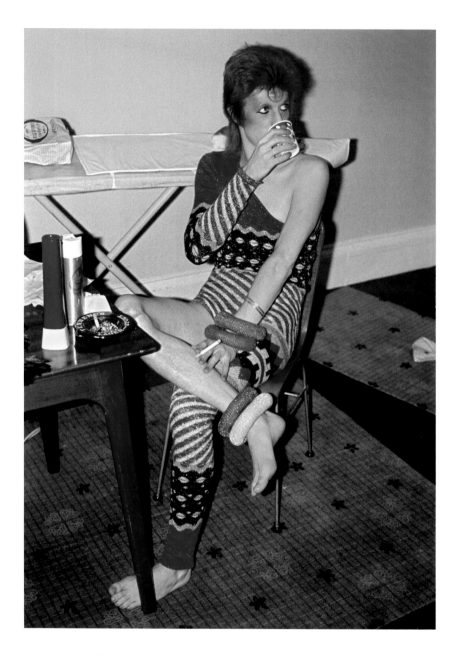

Scotland, May 1973. Taking a break to play table tennis during the recording
of *Pin Ups* at the Château d'Hérouville, just outside Paris, July 1973.

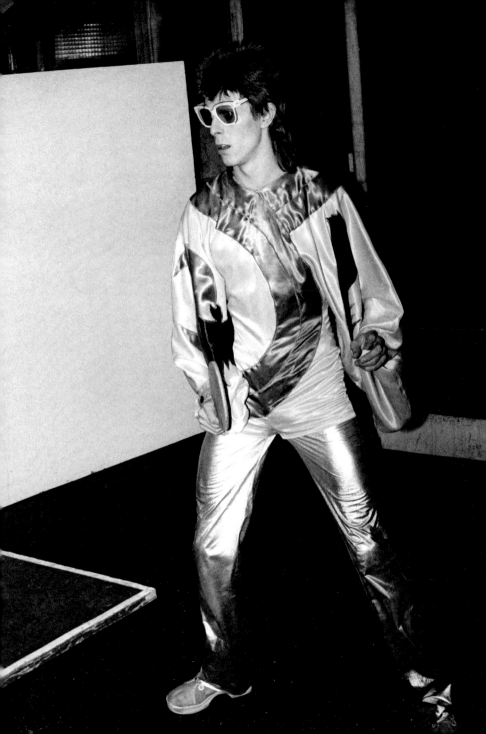

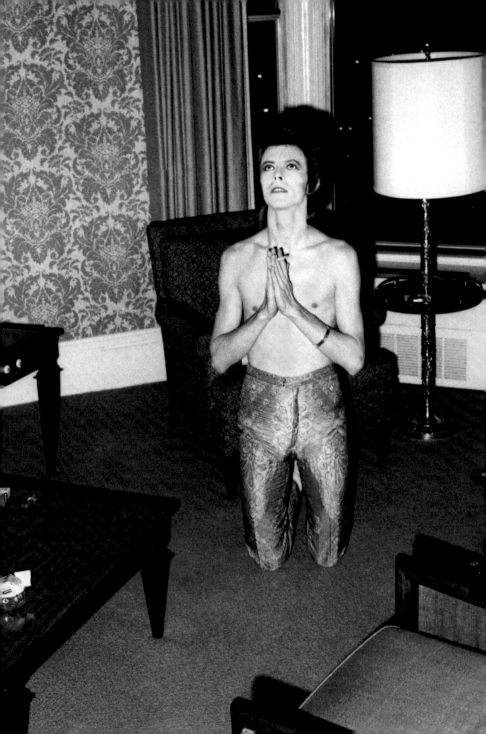

"THERE WAS A CORE OF DAVID
THAT WAS VERY STRONG, EVEN WHEN
HE WASN'T EATING MUCH. WHAT
GAVE HIM HIS POWER WERE HIS VERY
POWERFUL THIGHS AND A
NECK THAT WAS VERY LONG BUT
ALSO VERY STRONG..."

— MICK ROCK

Bowie on his knees pretending to pray
in his hotel room before a concert at the Chicago
Auditorium Theatre, 7 October 1972.

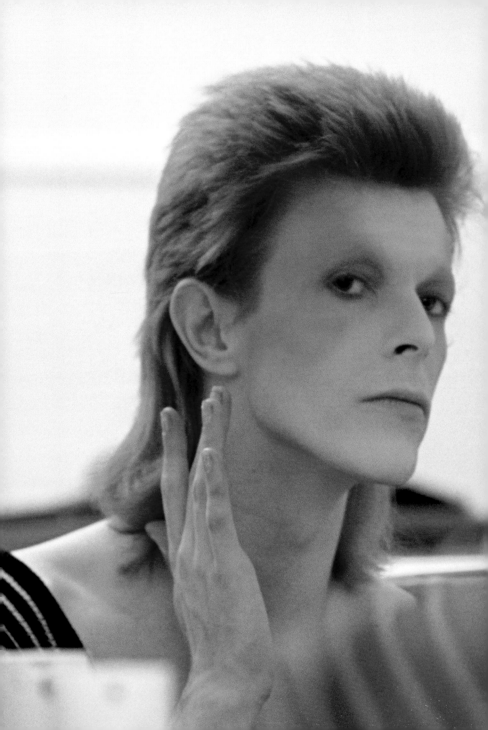

LADY STAR DUST

"THE BOY IN THE BRIGHT BLUE JEANS
JUMPED UP ON THE STAGE
AND LADY STARDUST SANG HIS SONGS
OF DARKNESS AND DISGRACE."

110–111 Caird Hall, Dundee, 17 May 1973.
Aberdeen Music Hall, 16 May 1973.

112

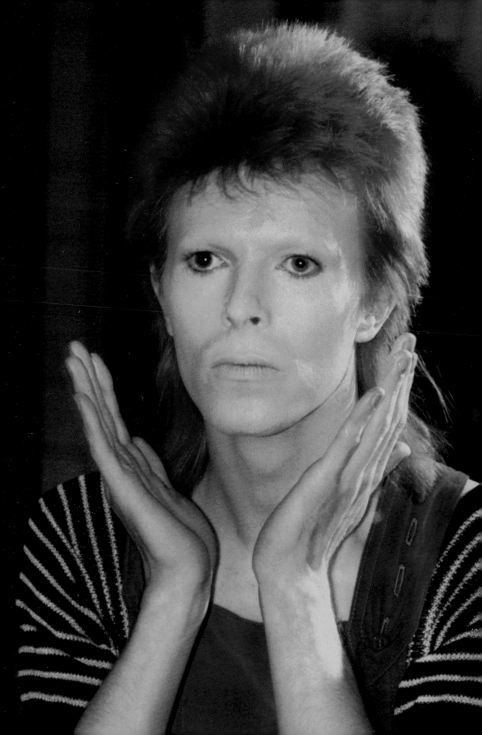

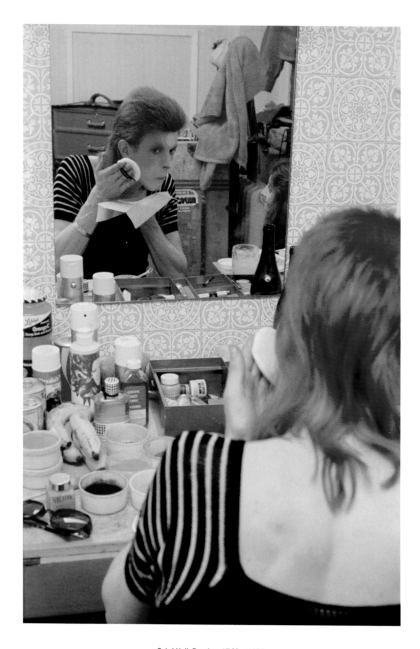

Caird Hall, Dundee, 17 May 1973.
Earls Court, London, 12 May 1973.

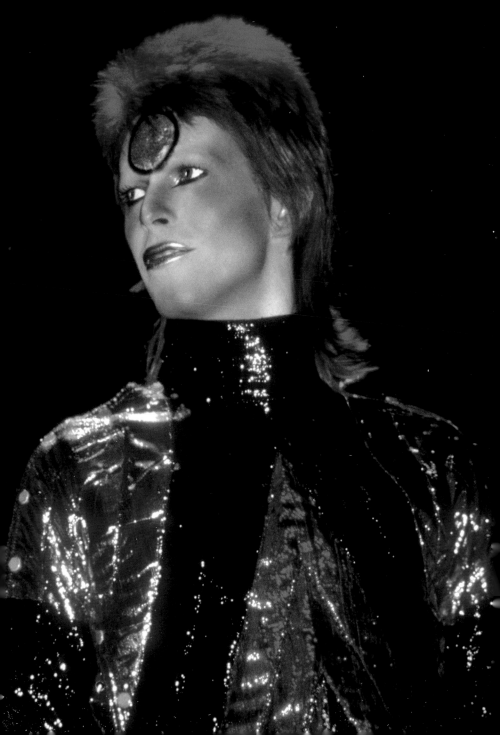

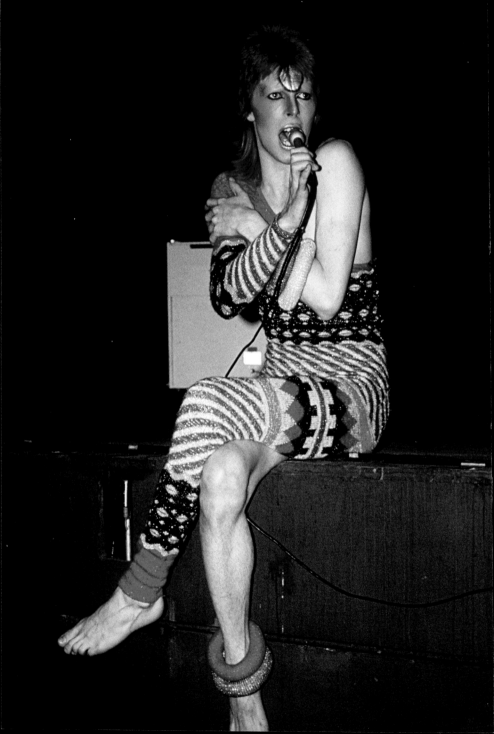

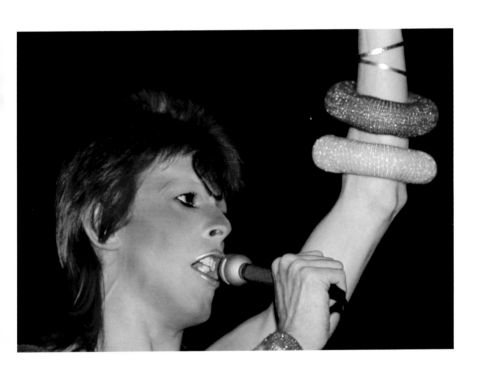

UK Summer tour, May–July 1973.
Hammersmith Odeon, London, 2 July 1973.

"DAVID WAS THREATENING BECAUSE
IT WAS A DIFFERENT CONSCIOUSNESS.
WHATEVER YOU WANT TO CALL IT – THE
FEMINISATION OF THE MALE OR WHATEVER
IT WAS – ANDROGYNY *WAS* A THREAT..."

— MICK ROCK

Earls Court, London, 12 May 1973.
Make-up by Pierre Laroche.

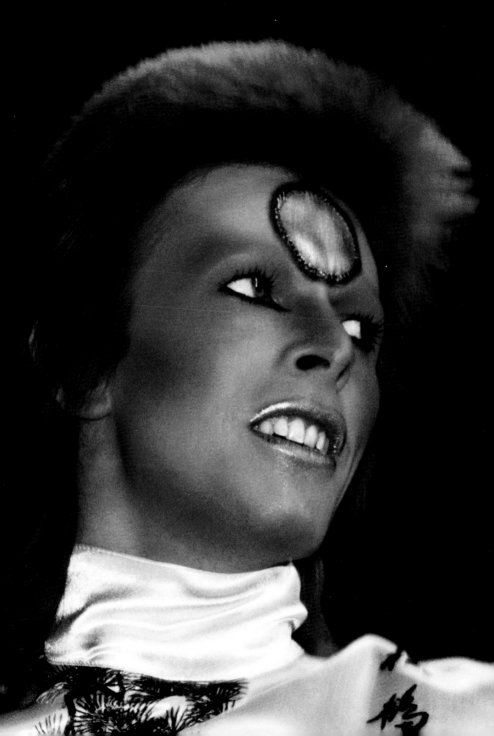

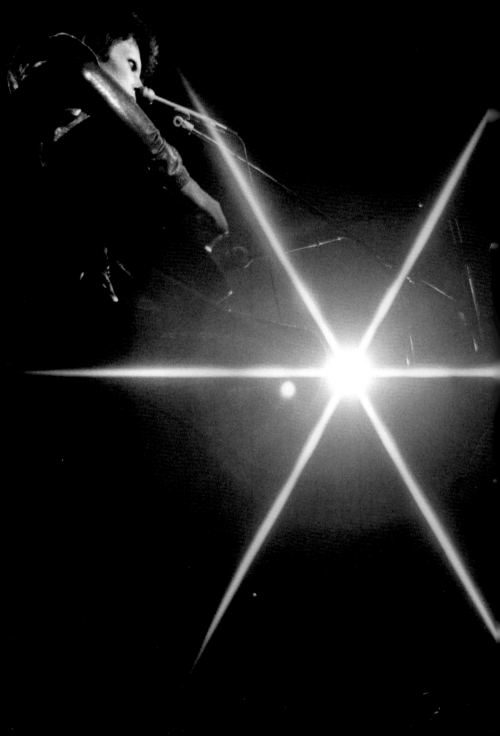

STAR

"I COULD FALL ASLEEP AT NIGHT
AS A ROCK 'N' ROLL STAR
I COULD FALL IN LOVE ALL RIGHT
AS A ROCK 'N' ROLL STAR."

120–121 Hammersmith Odeon, London, 2 July 1973.

123–125 Beverly Hills Hotel, 18 October 1972.
Bowie is trying out the jacket and belt he would wear for the promo film for his new single "The Jean Genie".

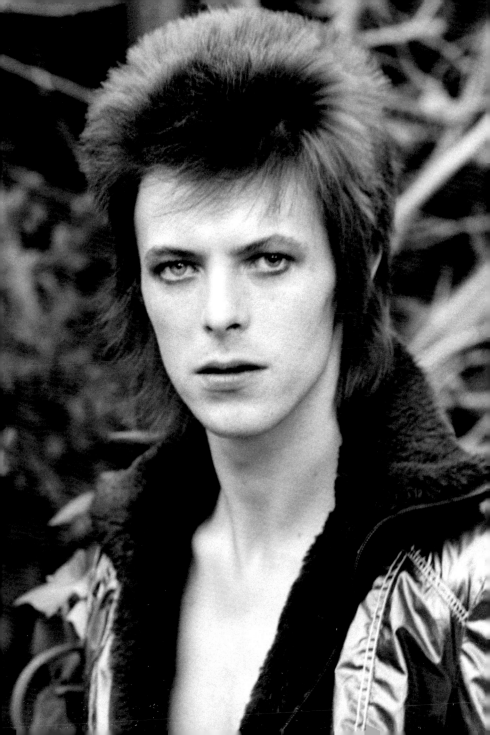

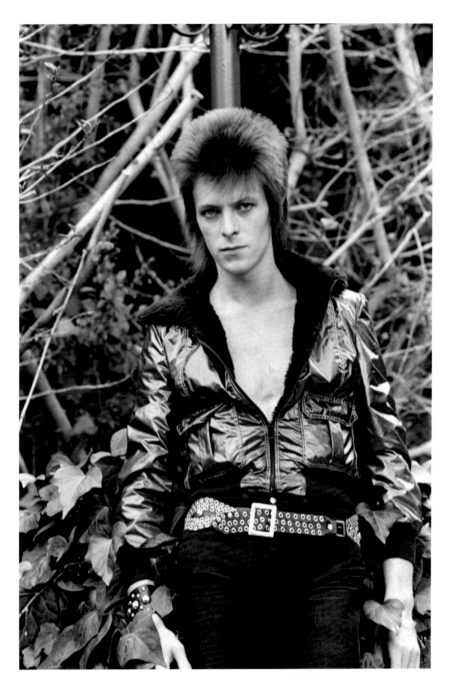

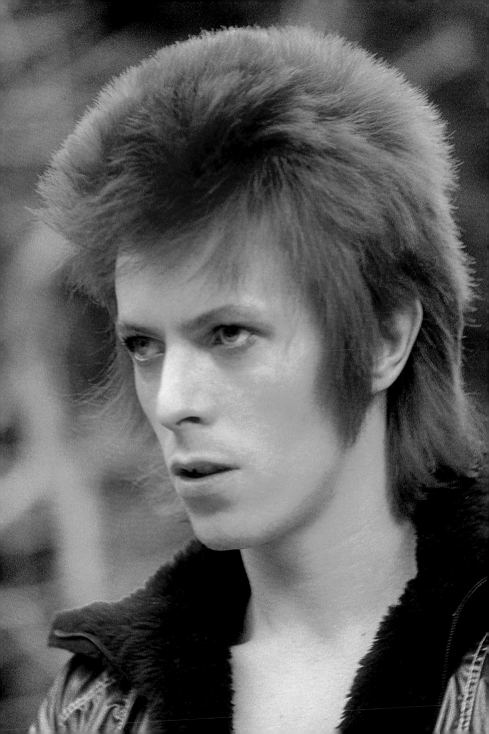

Hotel room, Chicago, 7 October 1972,
before going to the Auditorium Theatre to perform.

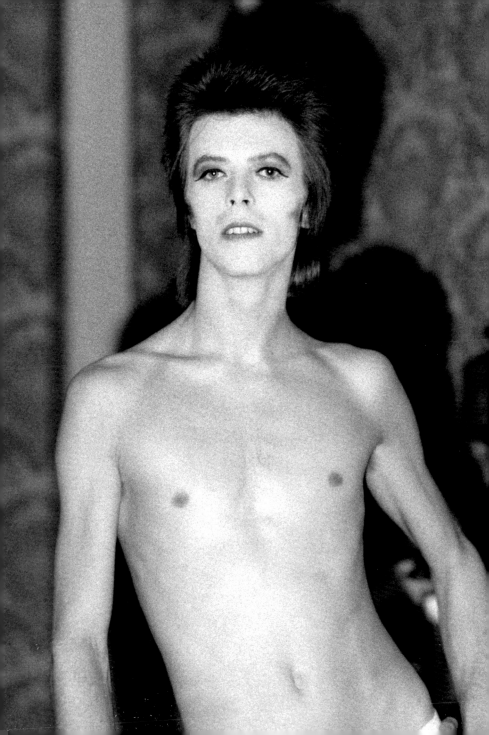

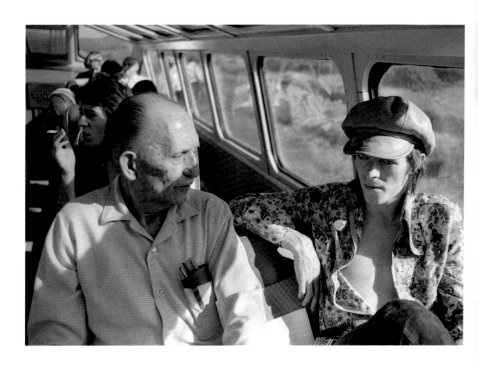

On the train from Kansas City to Los Angeles, 16–17 October 1972,
hanging with a gentleman with whom he'd fallen into conversation. Bowie is wearing
the pink cap he favoured on tour when he decided not to style his hair.

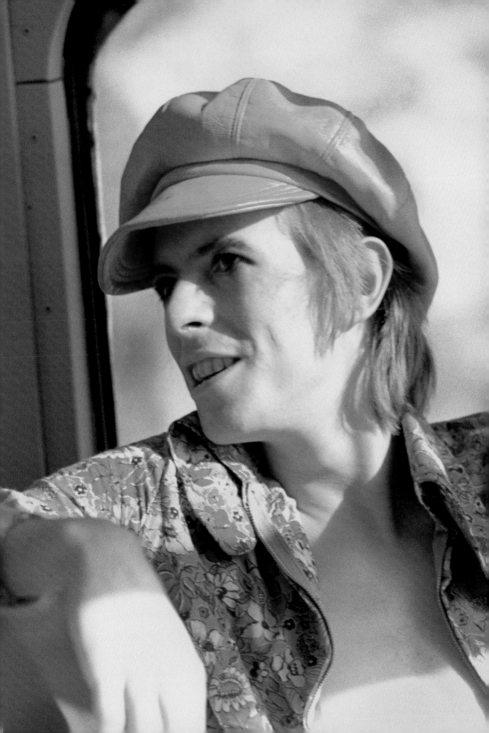

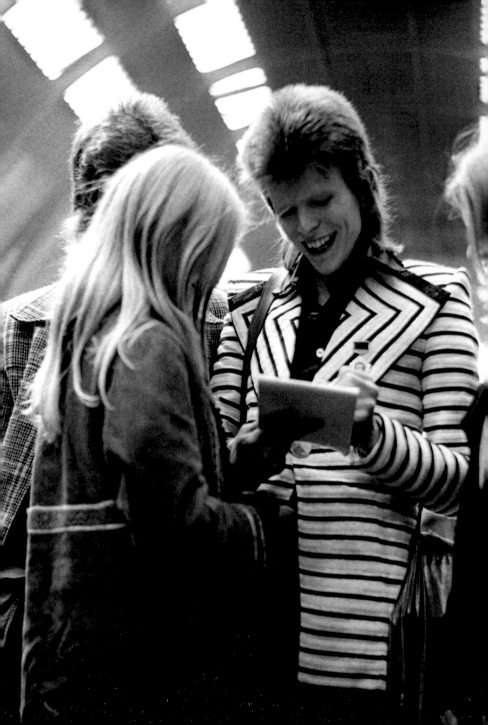

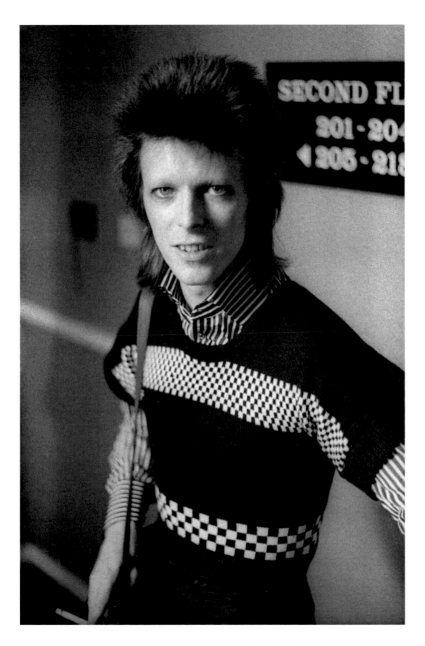

King's Cross station, London, 14 May 1973, signing autographs before taking a British Rail train to Aberdeen.
Arriving at Aberdeen Guild Street station, 14 May 1973.

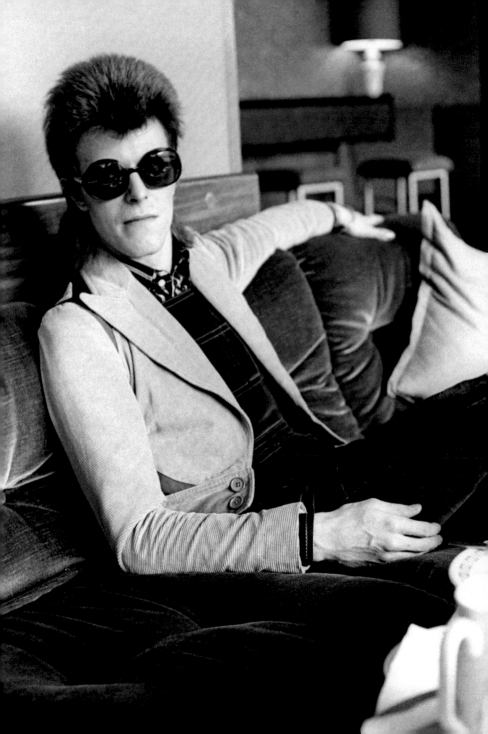

"WHEN DAVID MADE *ZIGGY STARDUST*,
WHICH IS ALL ABOUT STARDOM,
HE WAS NOT A STAR. THAT WAS THE
RECORD THAT MADE HIM A STAR..."
— MICK ROCK

Worcester, 4 June 1973.

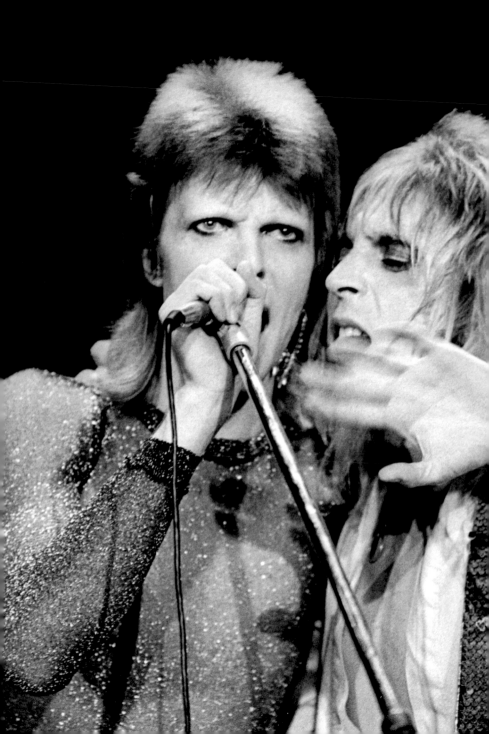

HANG ON TO YOUR SELF

"WELL COME ON, WELL COME ON
IF YOU THINK WE'RE GONNA MAKE IT
YOU BETTER HANG ON TO YOURSELF."

134–135 Hammersmith Odeon, London, 2 July 1973.
Bowie and Ronson, UK Summer tour, May–July 1973.

136

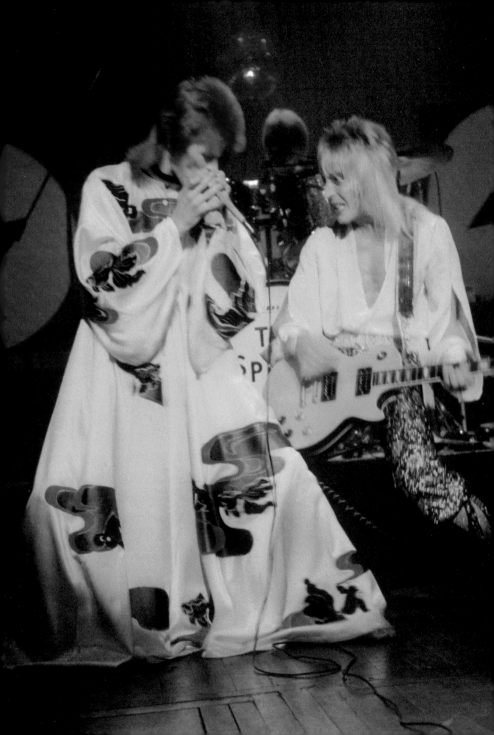

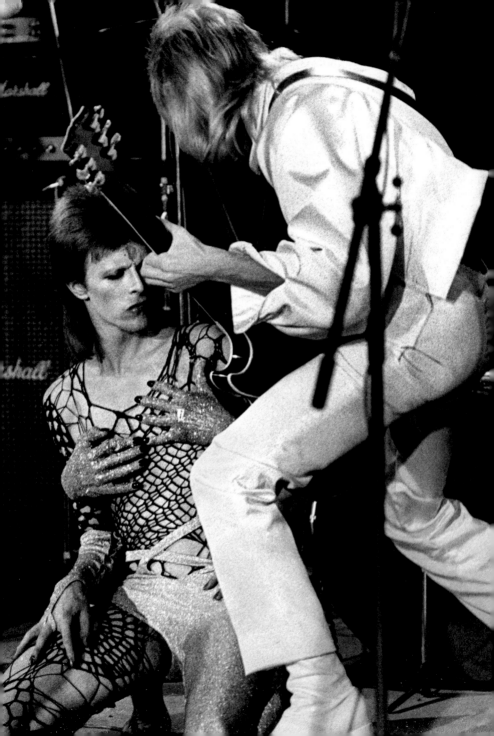

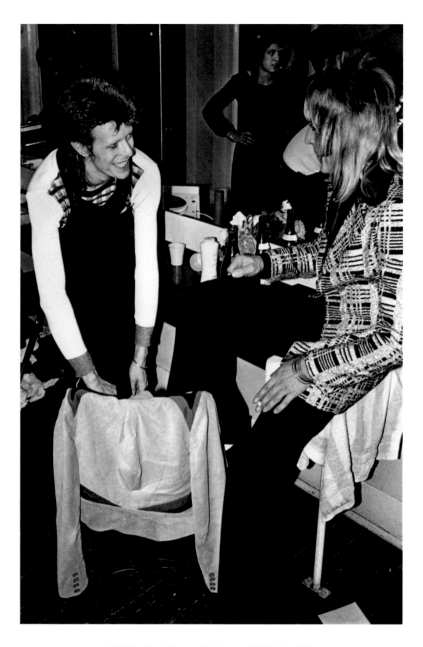

1980 Floor Show, Marquee Club, London, 18–20 October 1973.
Southampton Guildhall, 19 June 1973.

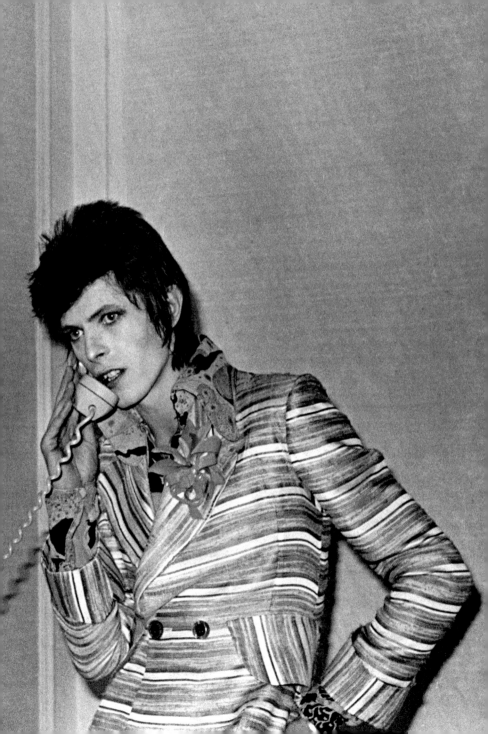

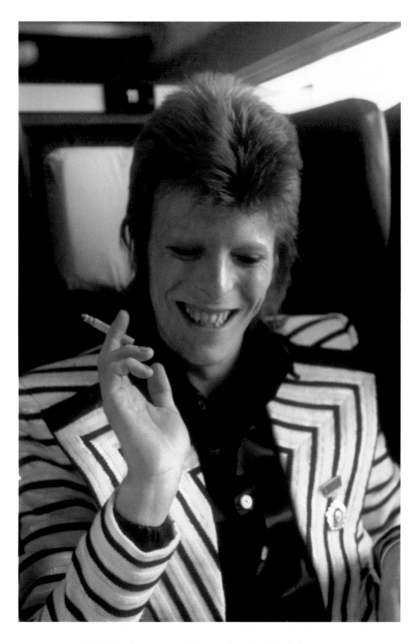

140–141 New York, 28 September 1972. Party at the Plaza Hotel after the Carnegie Hall show.
Taking the train from London to Aberdeen, 14 May 1973.

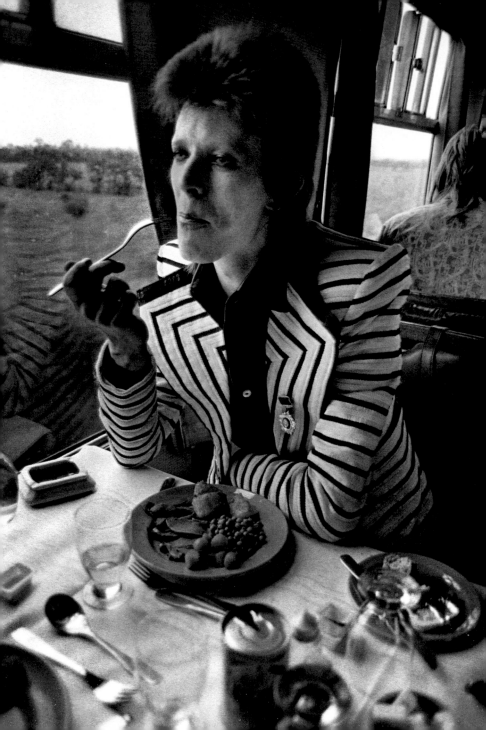

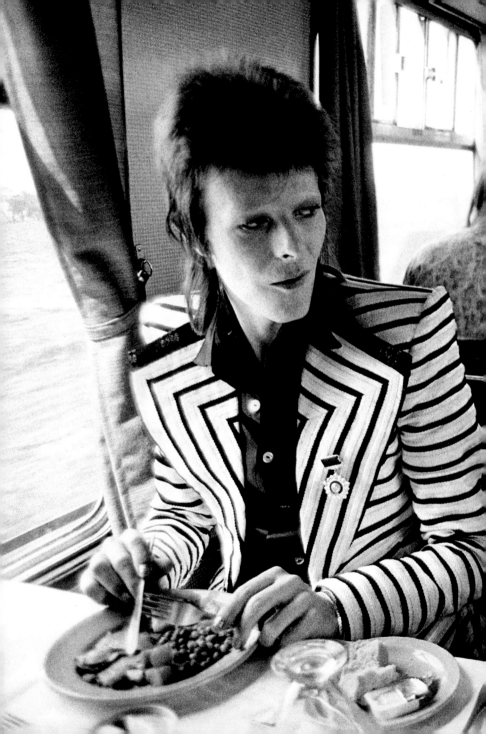

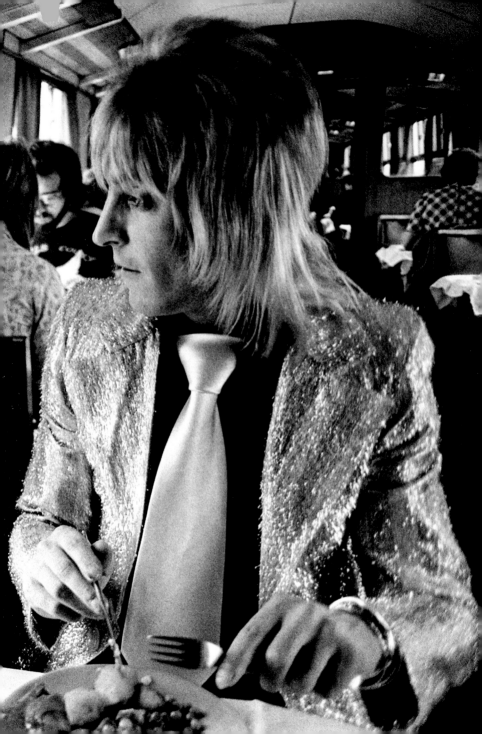

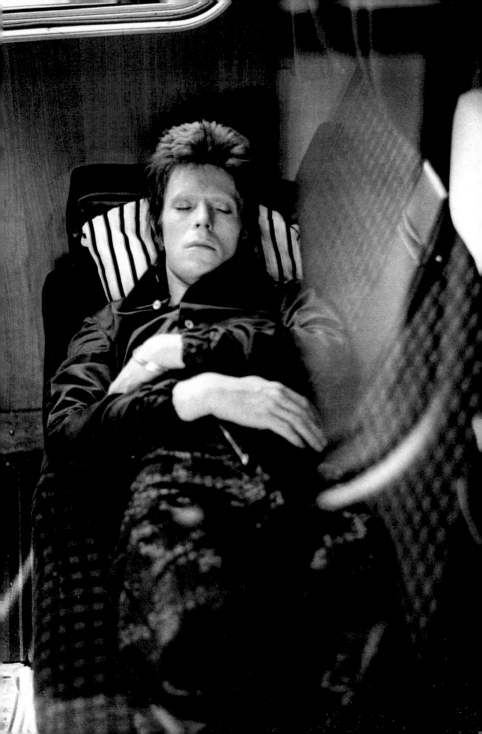

"I GOT PICTURES OF DAVID EATING, DRINKING COFFEE, HAVING A CIGGIE BEFORE GOING ONSTAGE, MAKING HIMSELF UP. I EVEN GOT SHOTS OF HIM ASLEEP..."

— MICK ROCK

144–145 Having a British Rail lunch on the train from London to Aberdeen, 14 May 1973.

Taking a nap on the train from London to Aberdeen, 14 May 1973.

IGGY STARDUST

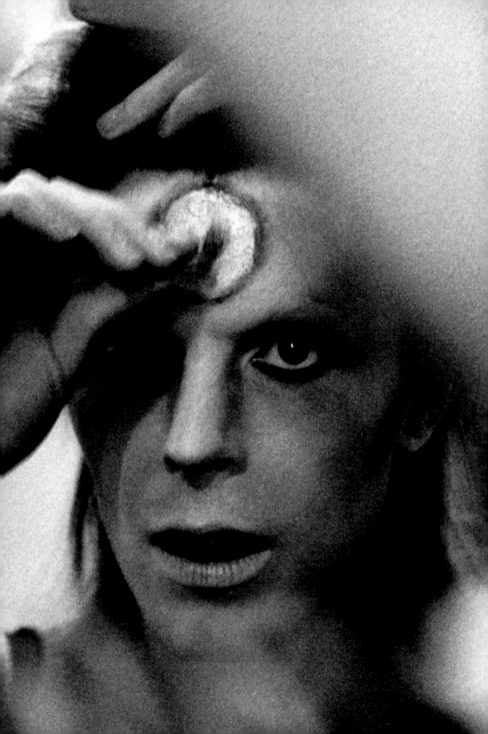

"ZIGGY REALLY SANG, SCREWED UP
EYES AND SCREWED DOWN HAIRDO
LIKE SOME CAT FROM JAPAN,
HE COULD LICK 'EM BY SMILING
HE COULD LEAVE 'EM TO HANG."

148–149 Aberdeen, 16 May 1973.

UK Summer tour, May–July 1973.

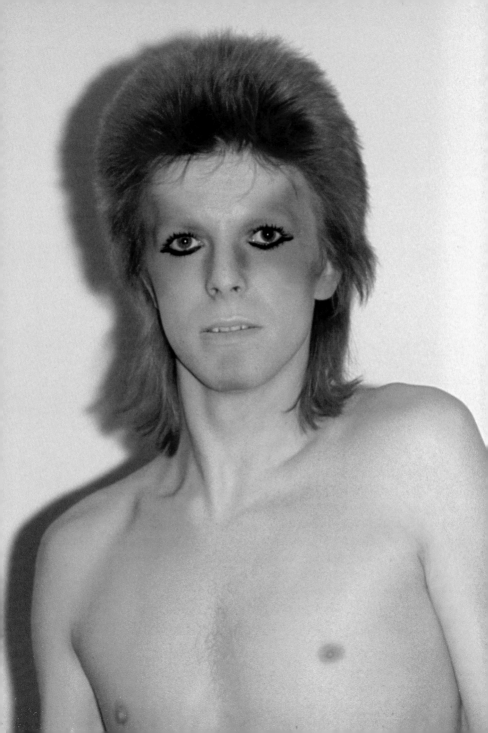

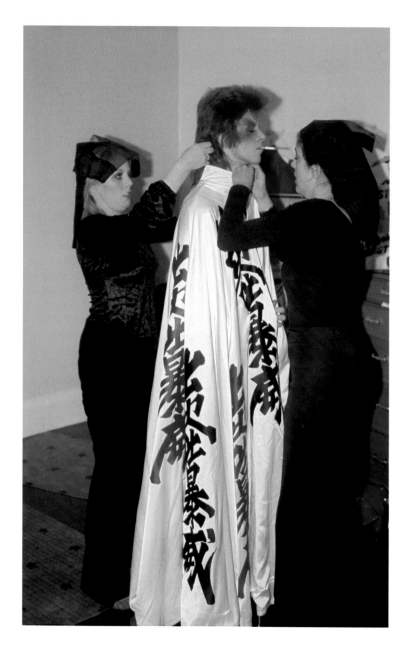

Hammersmith Odeon, London, 3 July 1973.
UK Summer tour, May–July 1973.

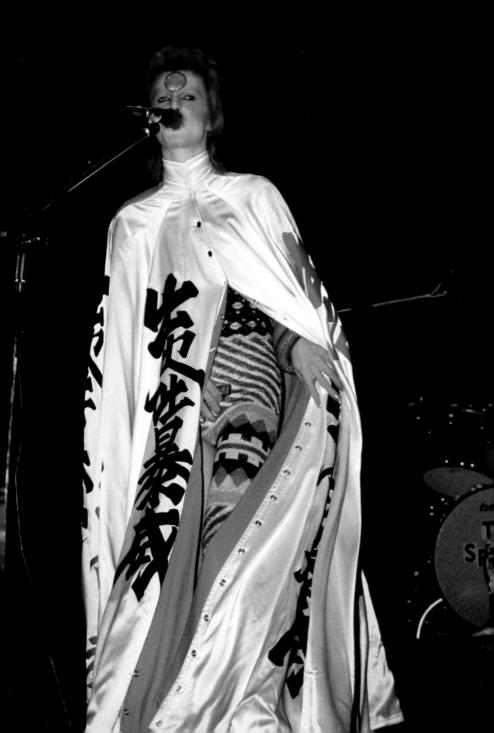

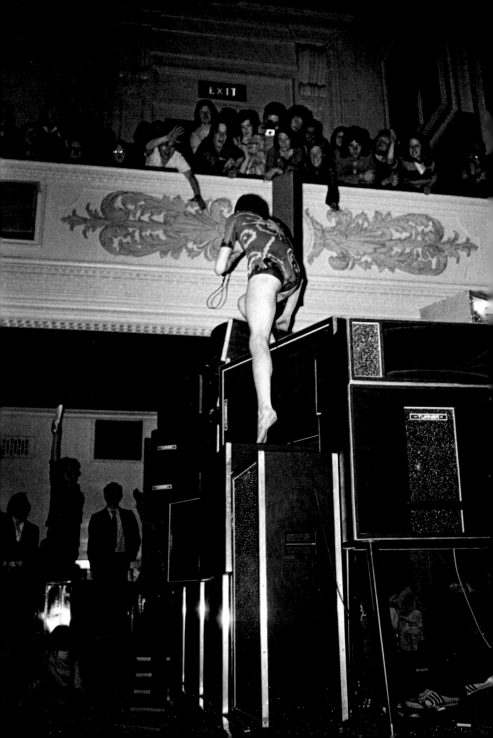

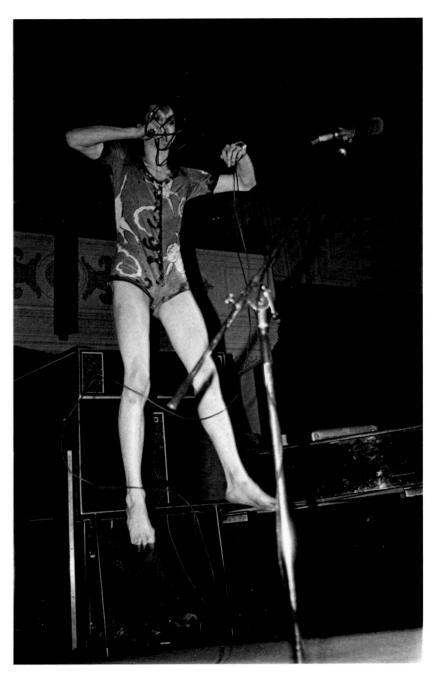

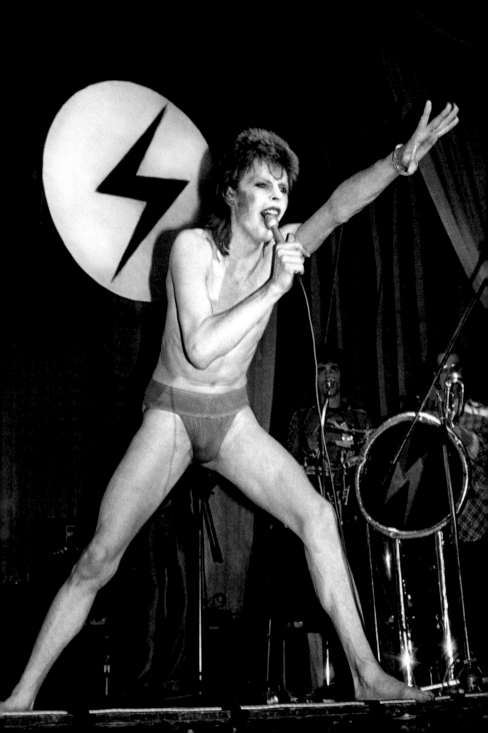

"THE EARLY ZIGGY STUFF WASN'T QUITE THE EXOTIC THING THAT DAVID BECAME — ESPECIALLY AFTER HE WENT TO JAPAN AND BAGGED A BUNCH OF COSTUMES FROM KANSAI YAMAMOTO..."

— MICK ROCK

154–155 Aberdeen Music Hall, 16 May 1973.
Green's Playhouse, Glasgow, 18 May 1973.

SUFF
RA
GETTE
CITY

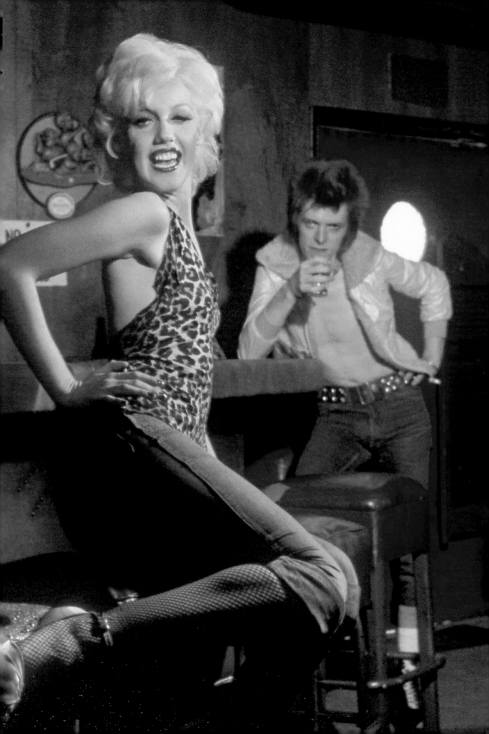

"OH DON'T LEAN ON ME MAN
CAUSE YOU AIN'T GOT TIME TO CHECK IT
YOU KNOW MY SUFFRAGETTE CITY
IS OUTTA SIGHT…SHE'S ALL RIGHT."

158–159 A local bar in the Hollywood Hills with
Cyrinda Foxe, 23 October 1972. This session was used as reference
for an illustration to promote "The Jean Genie" single.

161–163 "The Jean Genie" promo film with
Cyrinda Foxe, San Francisco, 27 October 1972.

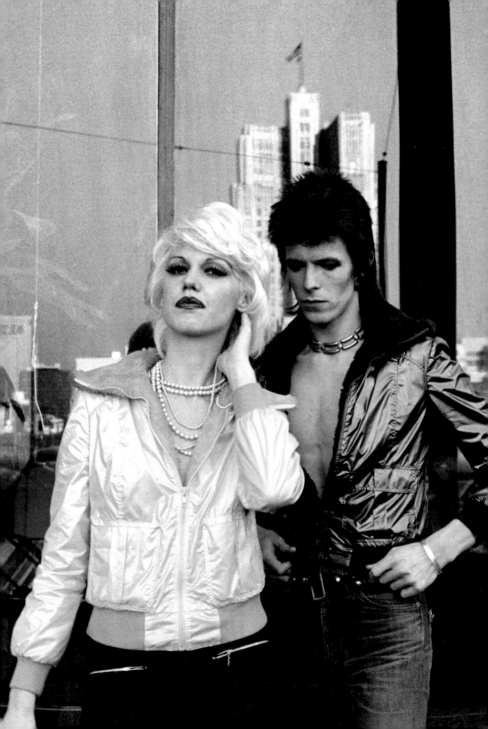

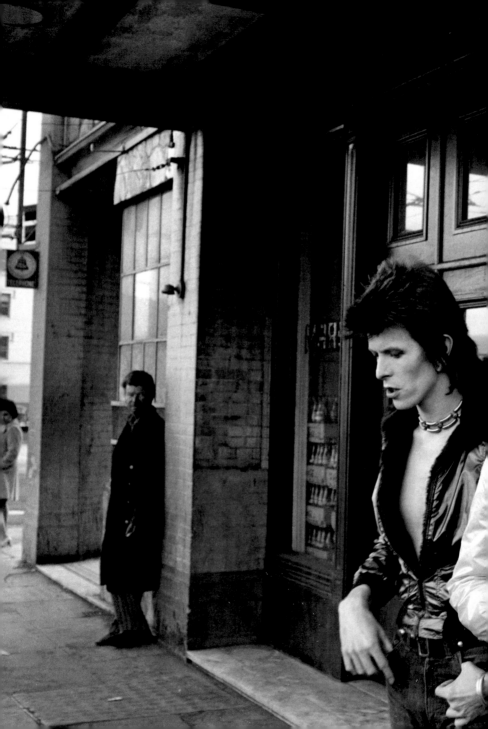

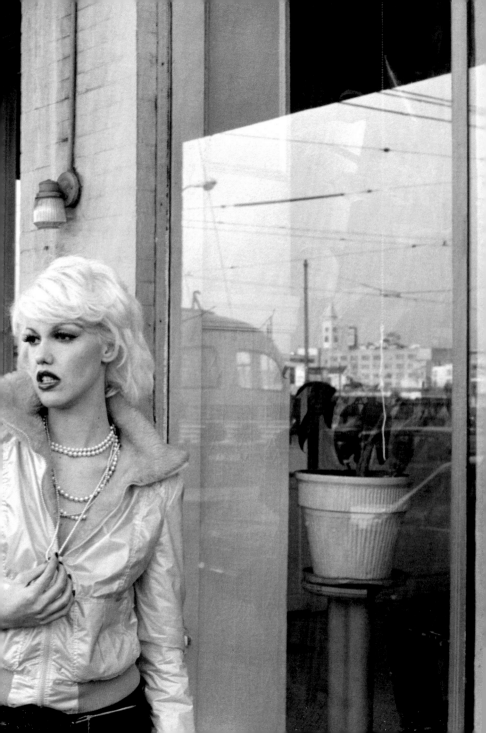

165–167 "The Jean Genie" promo film,
San Francisco, 27 October 1972.

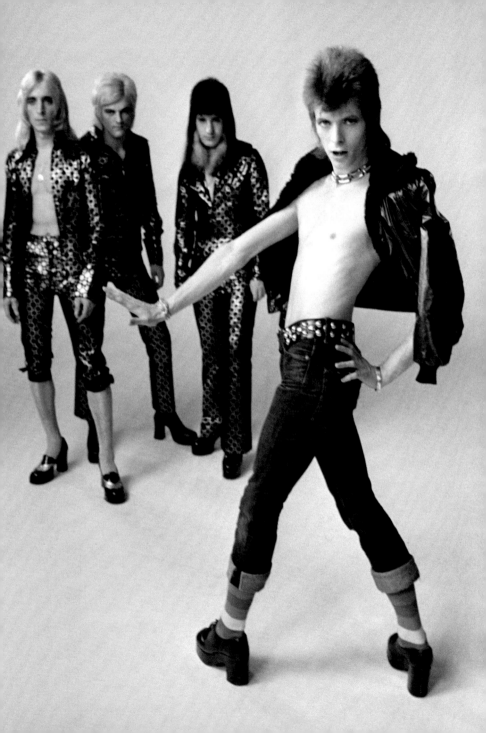

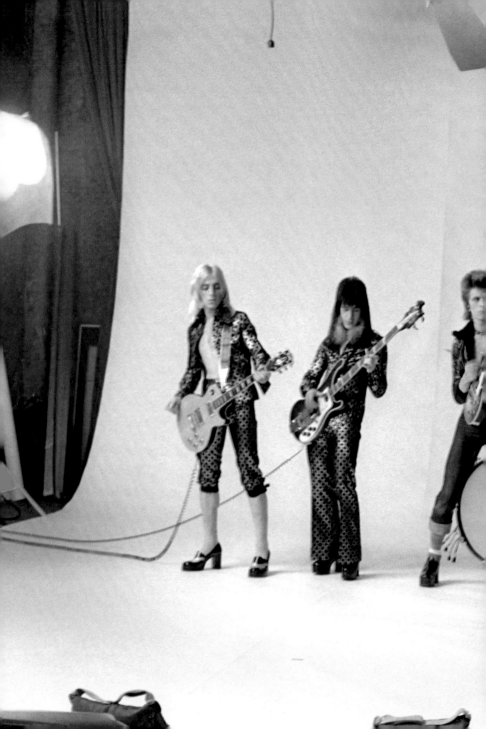

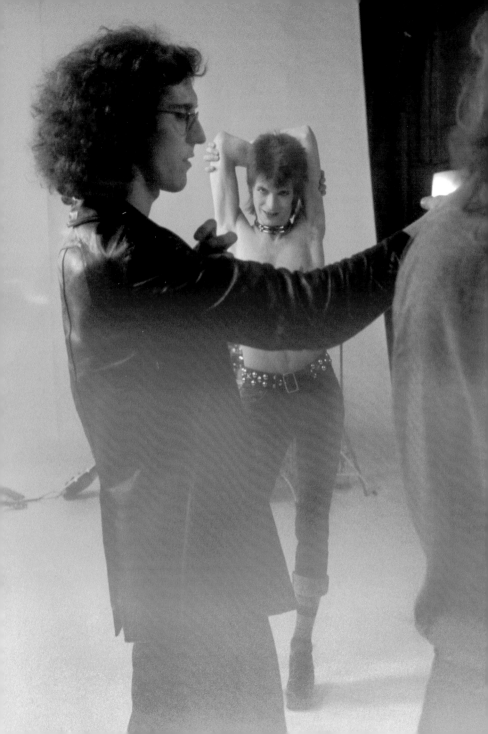

"WHEN YOU TRAVELLED WITH DAVID, THERE WAS A DECENT AMOUNT OF 'YOU FUCKIN' POOF!' BUT YOU GET INTO A KIND OF POCKET WHERE YOU'RE ALL IN IT TOGETHER AND ENJOYING THE ABUSE..."

— MICK ROCK

Rock directing Bowie in "The Jean Genie" promo film,
San Francisco, October 1972.

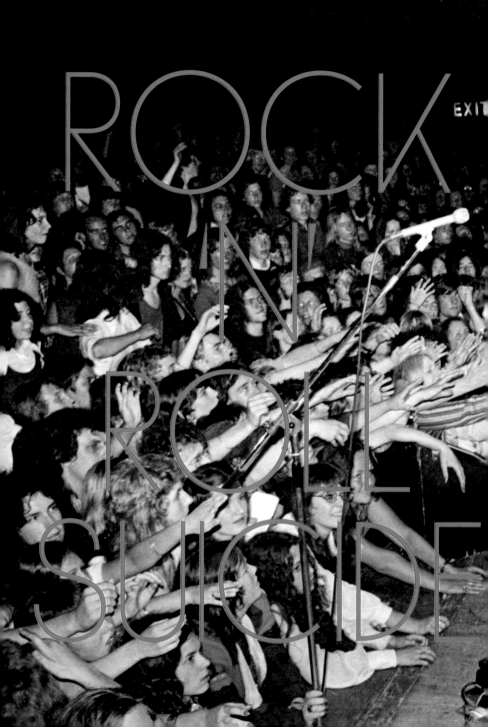

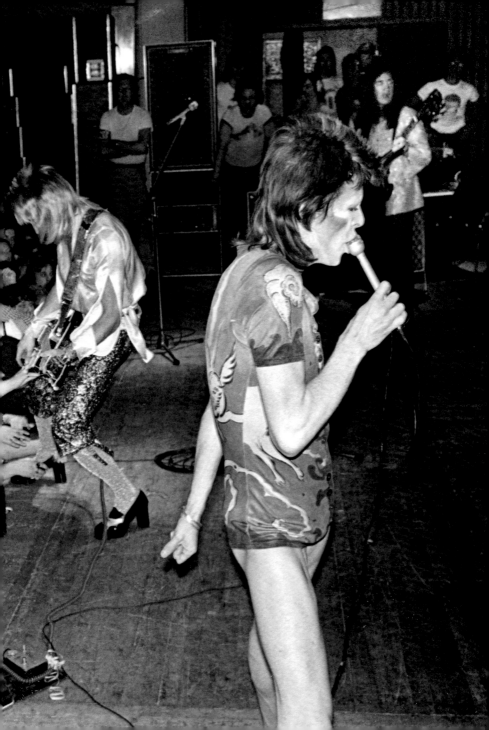

"LET'S TURN ON
AND BE NOT ALONE (WONDERFUL)
GIMME YOUR HANDS
'CAUSE YOU'RE WONDERFUL (WONDERFUL)
GIMME YOUR HANDS
'CAUSE YOU'RE WONDERFUL (WONDERFUL)
OH GIMME YOUR HANDS."

170–171 Southampton Guildhall, 19 June 1973.
Tower Theatre, Philadelphia, 1 December 1972.

172

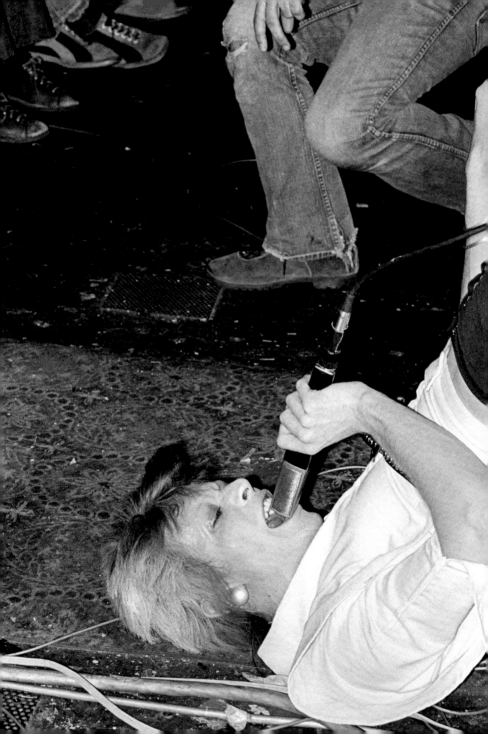

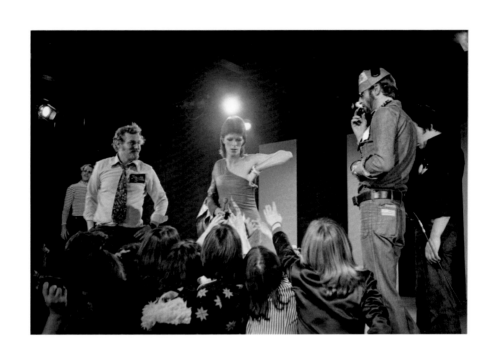

1980 Floor Show, specially filmed for the US TV
music programme *Midnight Special*, 19 October 1973.

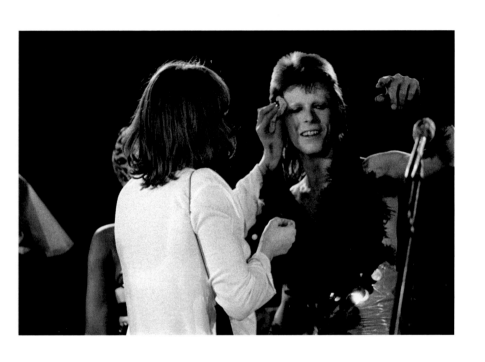

176–177 *1980 Floor Show.* Bowie was joined by Marianne Faithfull
in a nun's habit for a rendition of Sonny and Cher's "I Got You, Babe".

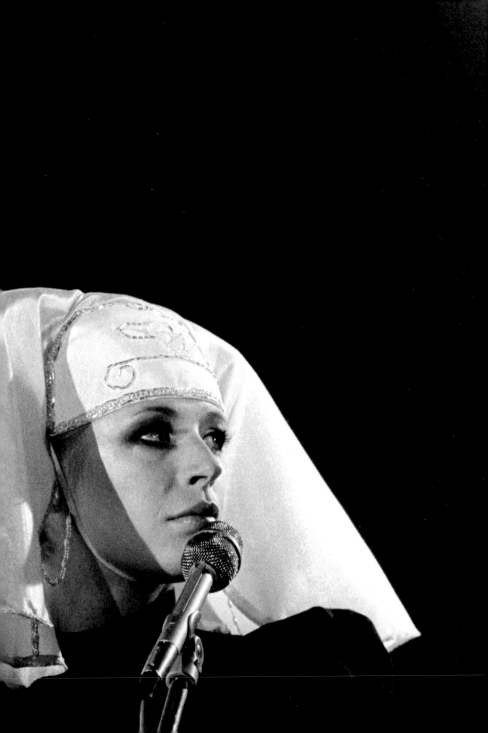

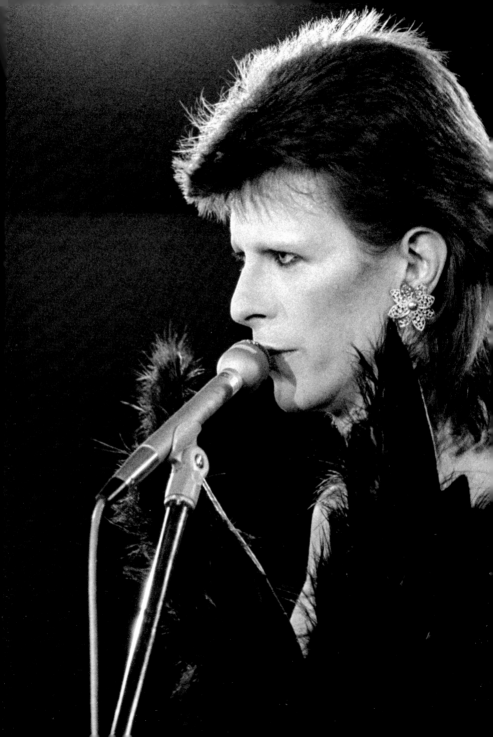

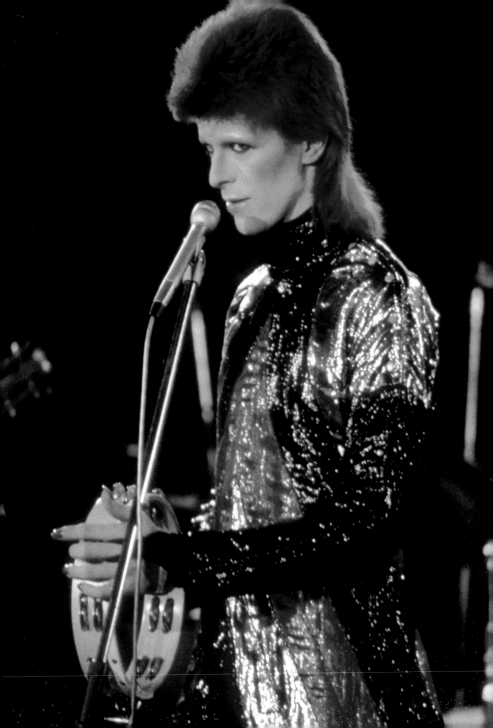

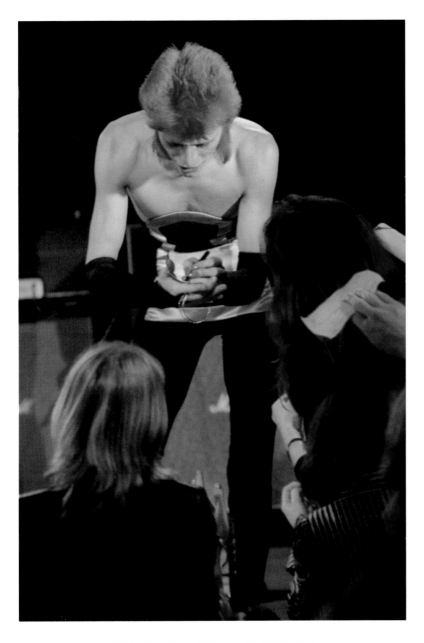

1980 Floor Show, Marquee Club, London, 18–20 October 1973.
1980 Floor Show. Taking a break between songs and signing an autograph.

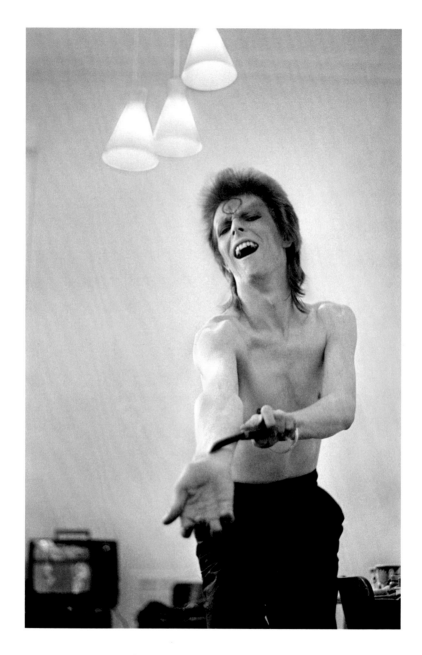

Aberdeen Music Hall, 16 May 1973, 9 p.m. show.
Bowie often performed two shows a night on this tour.

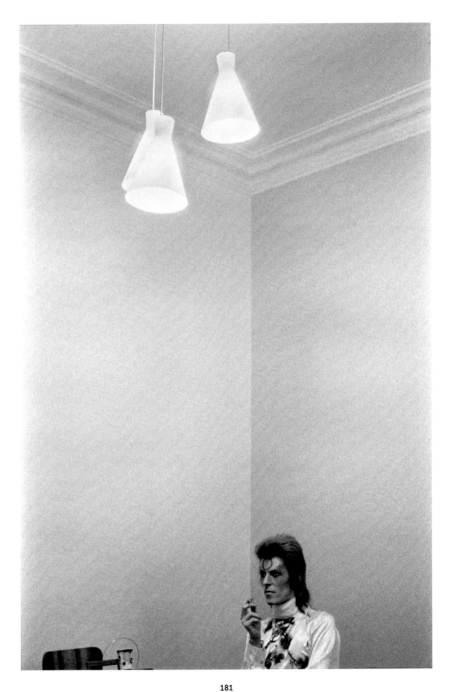

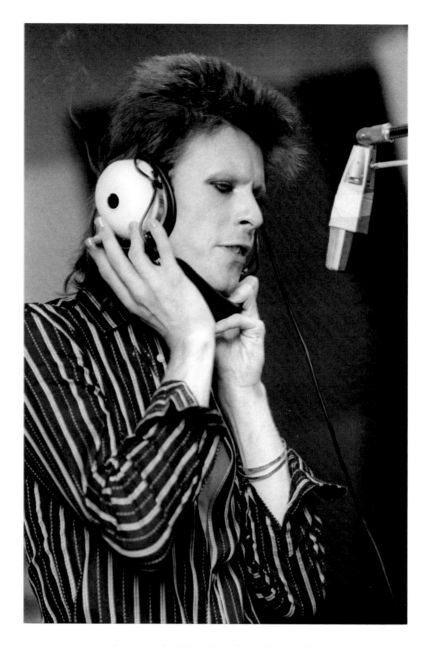

Recording *Pin Ups*, Château d'Hérouville, near Paris, July 1973.
Recording "The Man Who Sold the World" with Lulu at the Château d'Hérouville.

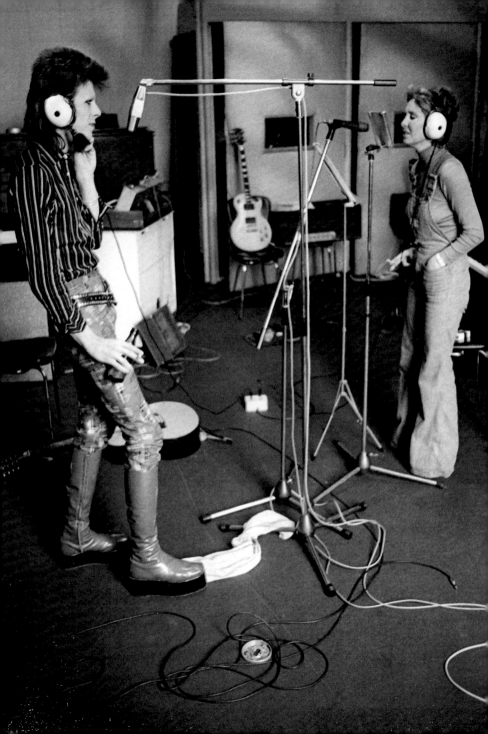

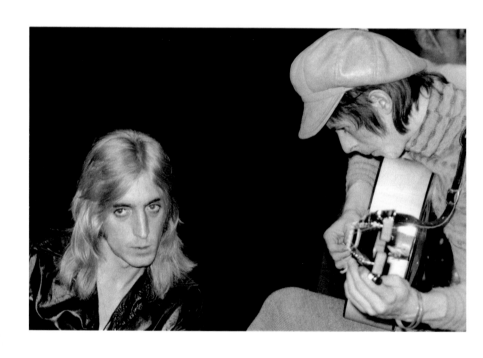

Sound check with Mick Ronson before a concert at
Chicago Auditorium Theatre, 7 October 1972.

Backstage before a concert at Birmingham Town Hall, England,
17 March 1972. The first photo Rock ever took of Bowie.

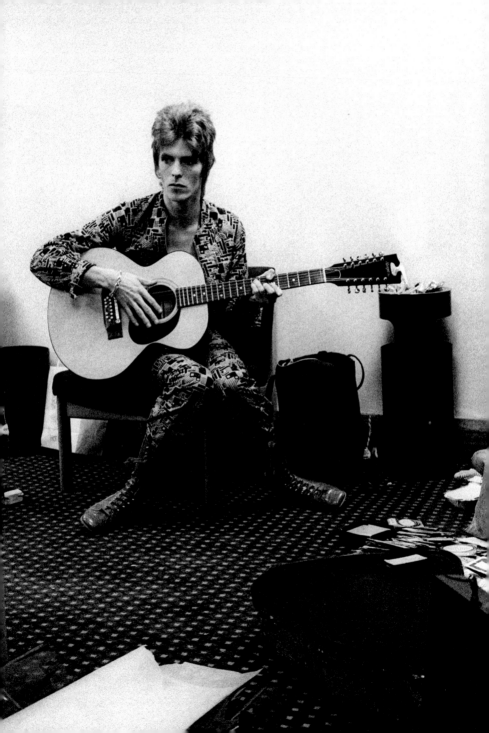

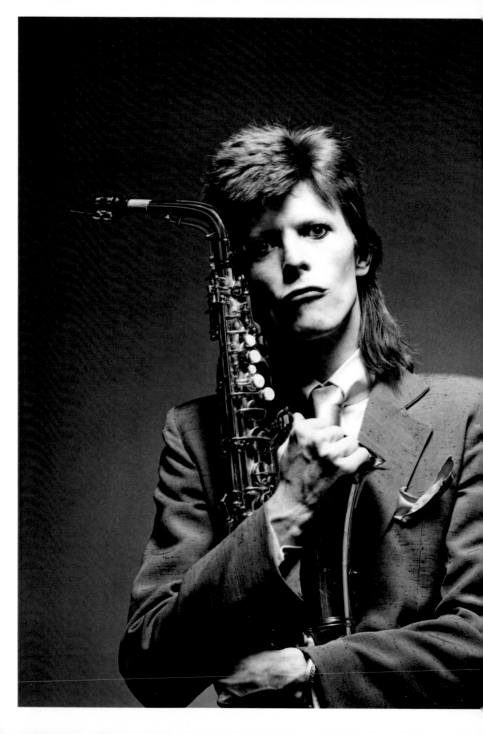

"DAVID KEPT CHANGING...DAVID WAS ALWAYS MUTATING."

— MICK ROCK

Pin Ups photo session, August 1973.

188–189 "The Jean Genie" promo film, San Francisco, 27 October 1972.

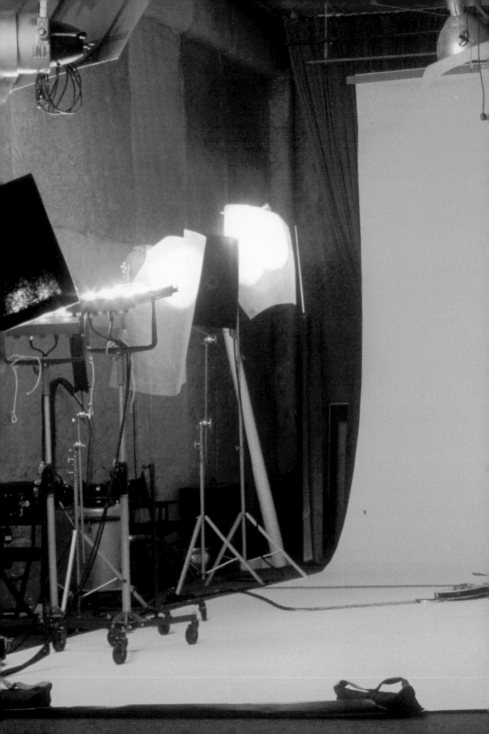

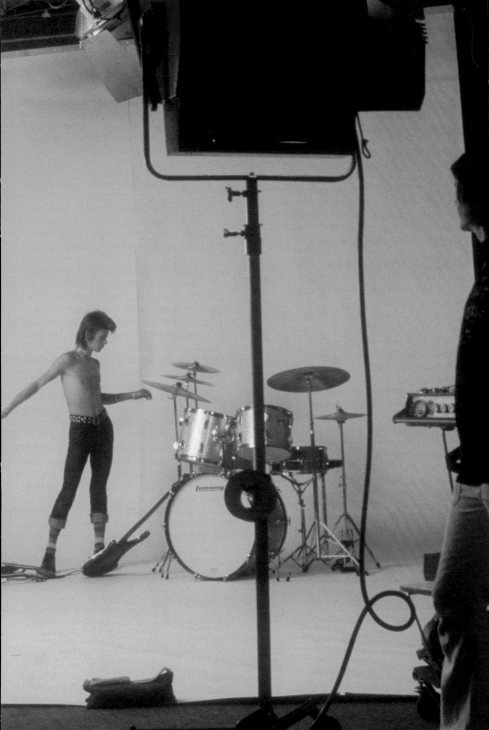

"IT DOES NOT MATTER WHO YOU ARE.
IT ONLY MATTERS HOW YOU RADIATE."

— YOGI BHAJAN

Someone decided that everyone in Bowie's entourage,
including Bowie himself, needed to have a photo ID headshot badge.
This was Bowie's. Cleveland, 22 September 1972.

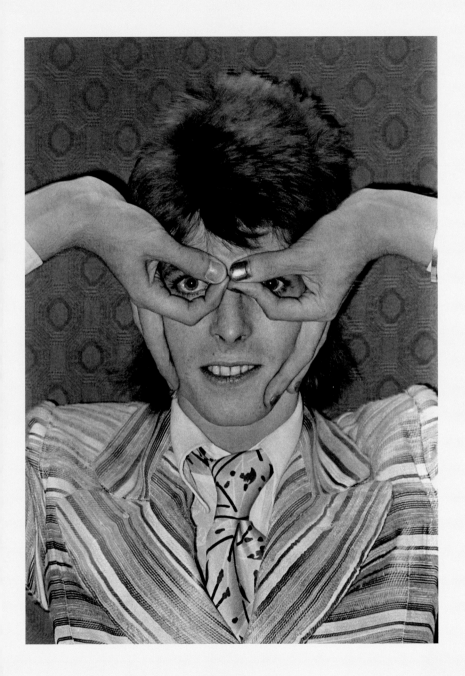

1 On the luxury liner *QE2*, Southampton, England, January 1973, heading for his second US tour. These are the only photos from the period in which he appears to have his hair greased back.

2–3 Bowie's home, Haddon Hall, Beckenham, England, late March 1972. Photographed in the bedroom of his one-year-old son Duncan.

4–5 UK Summer tour, 1973. Bowie usually did his own make-up and now was using a special Noh theatre palette, which he had brought back from his nine-gig Japanese tour in April 1973.

6–7 Bournemouth Winter Gardens, England, Summer tour, 25 May 1973.

8 Photo session for the *Pin Ups* album jacket. This was shot in a rented studio just off Piccadilly, London, in August 1973.

10 Earls Court, London, 12 May 1973. His first concert on the final Ziggy Stardust UK tour.

© 2023 TASCHEN GmbH
Hohenzollernring 53, D–50672 Köln
www.taschen.com

All photos © Mick Rock 1972, 1973, 2020
www.mickrock.com

All songs © 1972 Written by David Bowie.
Published by Tintoretto Music (BMI)
administered by Warner-Tamerlane
Publishing Corp., Screen Gems-EMI
Music, Inc. (BMI) o/b/o EMI Music
Publishing Ltd., BMG Blue (BMI).
Except "It Ain't Easy" © 1969 Written
by Ron Davies. Published by Irving
Music, Inc. (BMI).

Original edition © 2015 TASCHEN GmbH
Editor Reuel Golden, New York
All photos remastered and all art prints
Lucky Singh of Lucky Visuals Inc, New York

Printed in Italy
ISBN 978–3–8365–9403–5